Historic England

Coventry

David McGrory

AMBERLEY

Acknowledgements

Many thanks to Historic England, Rob Orland, John Ashby and Amberley Publishing for their assistance.

For Heather. Also to my late dear friend Trevor Beer MBE, FRZS, naturalist, author, artist, folklorist, protector of north Devon's wildlife ... national treasure.

First published 2017

Amberley Publishing
The Hill, Stroud, Gloucestershire, GL5 4EP
www.amberley-books.com

Copyright © David McGrory, 2017

The images on the following pages are ©Historic England Archive: 22 (lower), 23–25, 31–35, 49 (lower), 50, 52 (top), 56–58, 60 (lower), 61–70, 72 (lower), 73–77.

The images on the following pages are ©Historic England Archive. John Laing Collection: 37–46, 49 (upper), 69.

The images on the following pages are ©Crown Copyright. Historic England Archive: 48 (lower), 51.

The images on the following pages are ©Historic England Archive (Aerofilm Collection): 80–90, 93–95.

All other images, unless otherwise stated, are reproduced by permission of Historic England Archive.

The right of David McGrory to be identified as the Author of this work has been asserted in accordance with the Copyrights, Designs and Patents Act 1988.

ISBN 978 1 4456 7530 5 (print)
ISBN 978 1 4456 7531 2 (ebook)

British Library Cataloguing in Publication Data.
A catalogue record for this book is available from the British Library.

Origination by Amberley Publishing.
Printed in Great Britain.

Contents

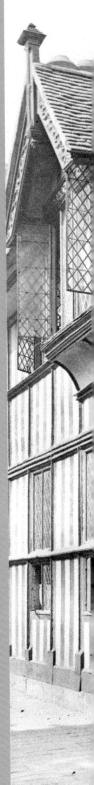

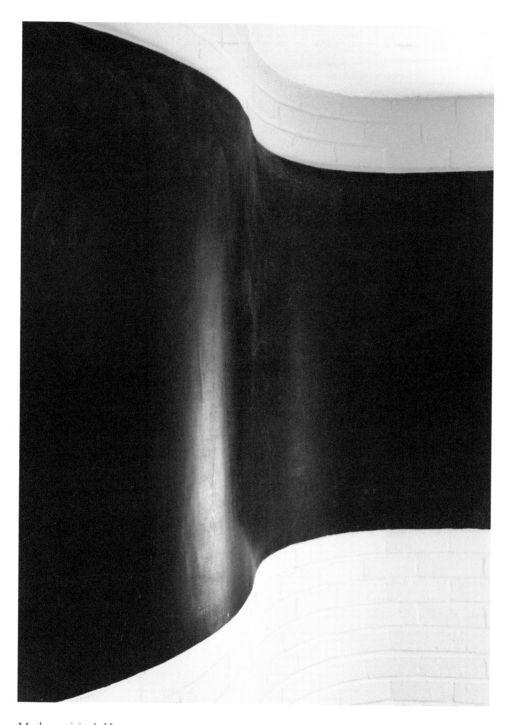

Mathematician's House
This is not a work of modern art, as you might assume, but the blackboard on the bedroom wall of Coventry University's Mathematician's House.

Introduction

Coventry has a long and varied history. There was some occupation during the Bronze Age and it has recently been confirmed that there was Roman occupation in the city centre. It grew with the foundation of monastic houses and prospered from the wool and cloth trade. The city wall was expanded, surrounding the city and keeping it safe. Coventry's merchants ranked among the richest in England and its famed true blue cloth was sold throughout Europe.

Coventry is a classic example of late fifteenth-century decline and later recovery following the Dissolution of the Monasteries. In the nineteenth century especially, its economy began to flourish again with the increasing production of ribbons, watches, bicycles and later motorcars; indeed the combination of the loom technology for ribbon-making and technology for watches were catalysts for the bicycle trade later.

Coventry's productivity made it a prime target during the Second World War and it was bombed a total of forty-one times. The defining raid that shocked the world was a sustained eleven-hour bombardment beginning on the evening of 14 November 1940. Coventry, so the German's said, had been 'Coventrated'. (This word comes from the German word *conventrieren*.) It is not known exactly how many people died that night and there is a mass grave for many of the dead. The city's morale was dented – but not beyond repair. Within a short time the ruined city was managing to function again and life continued amid the ruins.

After the war, rebuilding began as many looked to the future. The post-war rebuilding was the result of Donald Gibson's plan, which dated from before the war, to remodel Coventry. The need to rebuild a war-damaged city made this a reality. In this plan, Broadgate was somewhat reduced in significance as a route for transport with a road through the middle of a green area in the city centre. And old Coventry was transformed into a stylish city centre, into a place where people in their best 1950s clothes didn't look out of place.

The images in this book all belong to Historic England Archive and so this sets the tone and ultimate content of the book. Some buildings the reader might expect to see don't appear in these pages, while there are excellent photographs of modern buildings that might be unexpected because they are often overlooked. But the images from the archive focuses attention on good architecture: they can make the Jardine Crescent reminiscent of a crescent in Bath. This book helps us to appreciate both the city's surviving buildings and its newer additions.

Old Coventry

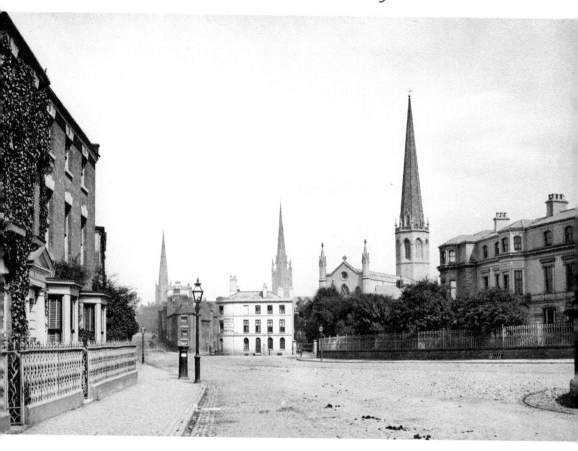

Above: Greyfriars/Hertford Street, 1868

This image is looking from Greyfriars Green towards Hertford Street and Greyfriars tower and spire. Coventry is known as the 'City of Three Spires', defining features of the Coventry skyline. These spires belong to the Old Cathedral Church of St Michael, Holy Trinity and Christ Church. On the left of the image is the Quadrant, completed in 1863 on part of the Sheriff's Orchard. The last section of the Quadrant on the right was home to renowned children's author Angela Brazil. The building in the centre is the Temperance Hotel. Here many alighted after a short carriage journey from Coventry station. On the left and in the foreground is Warwick Row.

Opposite: Knaves Post, 1868

This image was taken around 1868 and is of the old knaves post set in a niche in a building near the corner of Much Park Street. It stood here for over 200 years. The knaves post is made of bog oak and appears to be a Bronze Age deity, mirroring others found in Britain and the Continent. Its face was re-carved in the nineteenth century. The buildings are now gone, but the image remains in the museum.

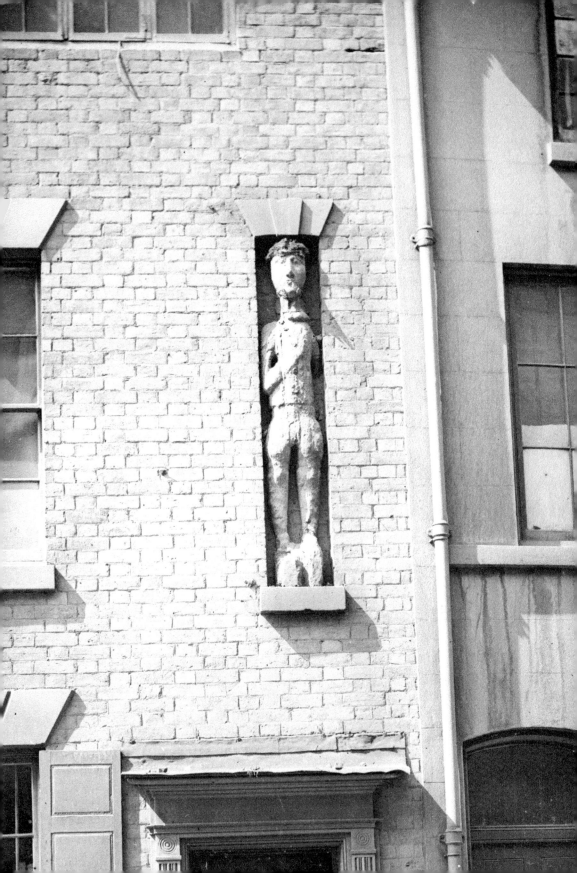

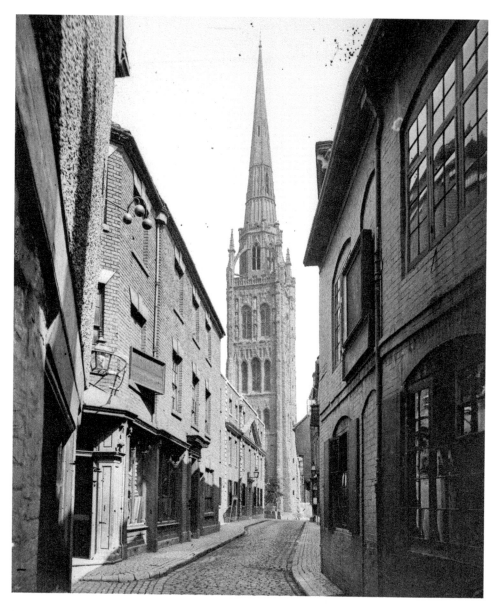

Pepper Lane, 1870

Pepper Lane, previously known as Gaol Lane, was once an extension of Bailey Lane. This image, taken around 1870, shows the Toby Inn on the right and the Prison Governor's House (left) at the bottom of the lane, built in 1772–73. Opposite stands the Golden Cross, and the magnificent tower and spire of St Michael's dominates the scene. There have been three cathedrals in Coventry: the medieval Cathedral of St Mary belonged to the priory. In the 1540s the seat of the diocese of Coventry and Lichfield moved to Lichfield. There was no cathedral in the city for nearly 400 years. But in 1918 the new diocese of Coventry was formed and the old parish church of St Michael's became the new cathedral. This was destroyed in 1940 and the new one built next door.

Bablake School and Bond's Hospital, 1870

This photograph, taken around 1870 looking up Hill Street, shows Bablake School and Bond's Hospital. Bablake School was founded as a Blue Coat school in 1560 by the mayor and council using charitable gifts. Thomas Wheatley, often referred to as the founder, made his donation to the school in 1563. In 1890 the school moved to its present site on Coundon Road, grew impressively and changed its charitable uniform and its ambitions to one that more resembles a public school.

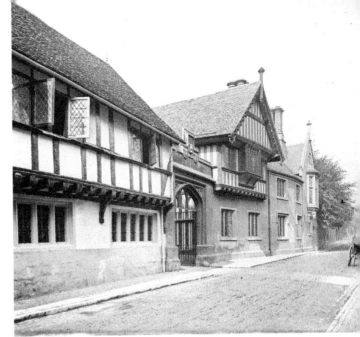

Bond's Hospital

Taken at the same time as the previous image, this photograph shows Bond's Hospital from the quadrangle it sits in. Boys from the adjoining Bablake School sit outside. Bond's Hospital was founded by Thomas Bond, a mayor and draper who gave the Corporation land and property to found a bedehouse for ten aged men and one woman. The foundation date is usually given as 1506 as this was probably the year the first inmates took residence, but Thomas Bond gave landed property for it in 1497 to raise money for its creation. The building still serves its original function.

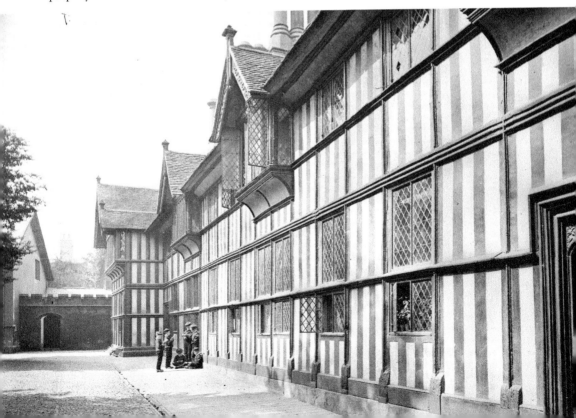

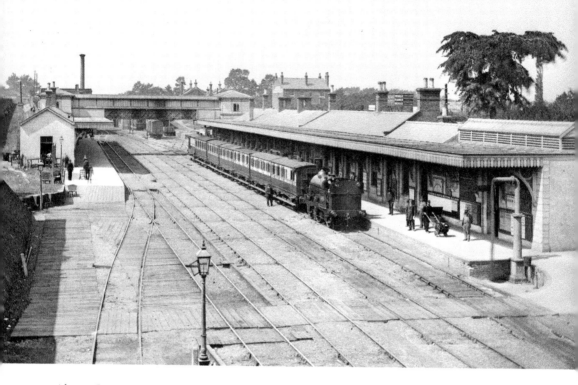

Above: Coventry Station, 1874

This photograph, taken in 1874, shows the LNWR 'Bloomer' class engine preparing to shunt carriages. The station, which lies on the Birmingham–London line, was opened in 1838. When the line opened the fare to London was £1 7s 6d. By 1910 the journey had been cut from 4¾ hours to two hours. In the background on the right above the station the Railway Inn can be seen, later called the Rocket. This inn was demolished in 2016.

Opposite: Ford's Hospital, 1880

A group of children pose outside of Ford's Hospital, also known as Greyfriar's Hospital, in Greyfriar's Lane around 1880. It was founded as an almshouse in 1509 for five men and one woman under the will of William Ford, a Coventry merchant. The number of residents changed in 1517 to six poor men and their wives but in the eighteenth century up until recent times was exclusively for women. The beautifully decorated building has heavily carved bargeboards.

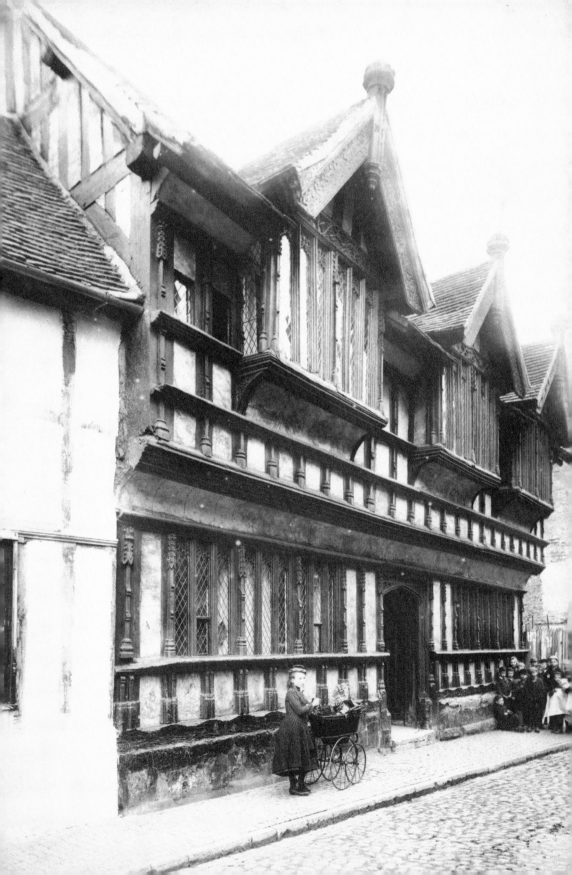

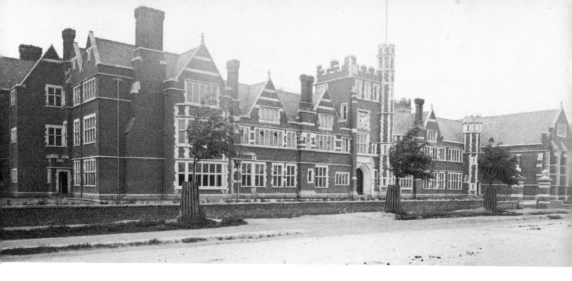

Above: King Henry VIII Free Grammar School, 1885

The new building of the King Henry VIII Free Grammar School, photographed on the 18 June 1885. When the old grammar school closed in Hales Street its pupils moved to this impressive building off the Warwick Road. Today this building is an independent school of 725 pupils run by Coventry School Foundation. On the night of 8–9 April 1941 the school suffered extensive bomb and fire damage, but it was subsequently rebuilt. Its most famous pupil perhaps is the poet Philip Larkin, although the school does have many other notable, if less well-known, former pupils.

Below: Butcher Row, 1890

This remarkable piece of old Coventry, Butcher Row, photographed around 1890, was one of Coventry's most loved, painted and photographed streets. It contained buildings dating from the fourteenth to nineteenth century and was demolished wholesale in 1936 to build Trinity Street to give motorcars easier access to Broadgate – ironically the top of Trinity Street is now pedestrianised!

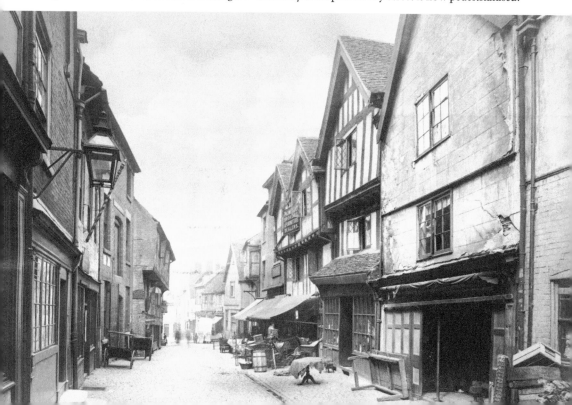

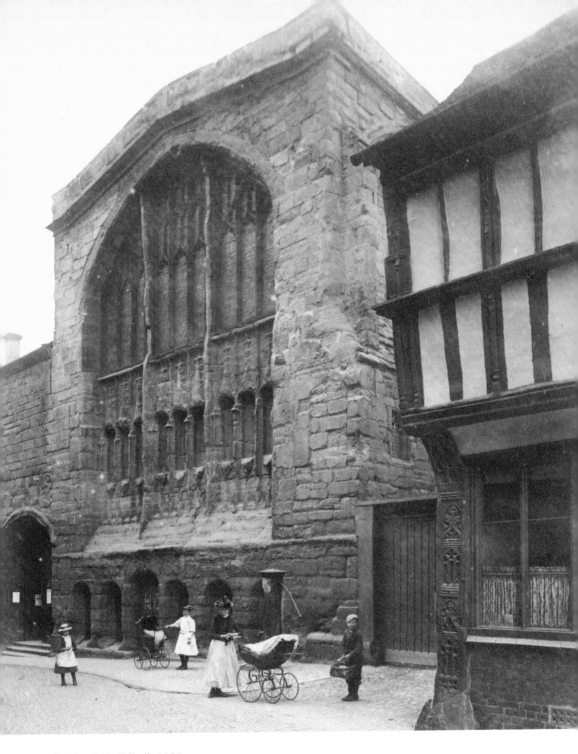

St Mary's Guildhall, 1890

This image shows St Mary's Guildhall photographed from Bayley Lane around 1890. The red-sandstone hall was started in 1340, built originally by the Guild of St Mary, which later became the Guild of the Holy Trinity. Originally built for rich Coventry merchants, five years later it also became the seat of power for the City Council and is still maintained by them.

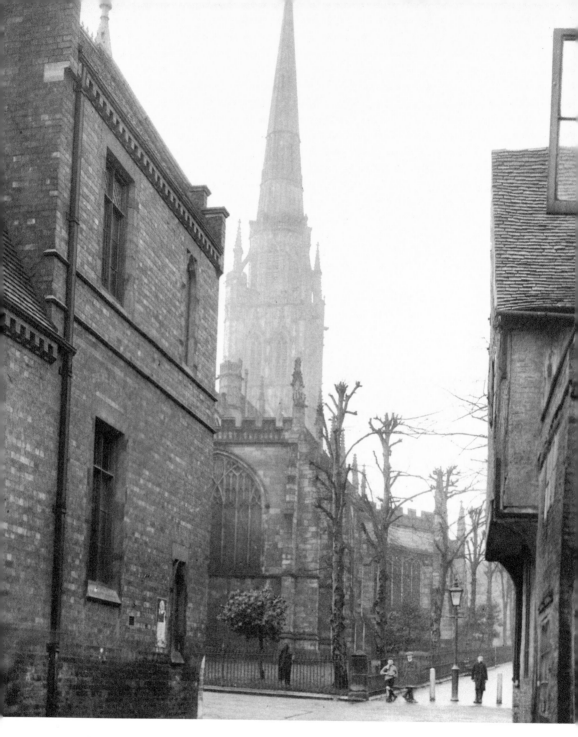

St Michael's, New Street, 1900

This image is looking down New Street towards St Michael's Church around 1900. The street largely survived the blitz but was demolished for the building of the Lanchester Polytechnic, now Coventry University. The building on the right corner still contained medieval stonework and was known as the Chapel of the Cross.

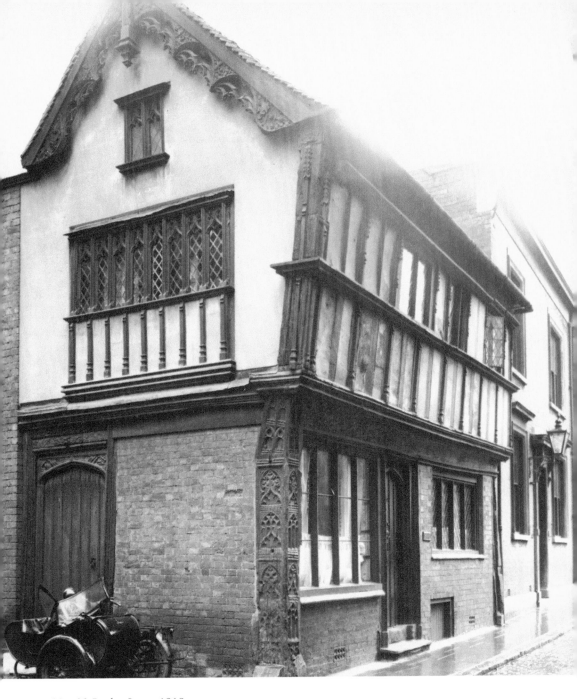

No. 22 Bayley Lane, 1918
No. 22 Bayley Lane is photographed here around 1918. This fifteenth-century building, a medieval merchant's house, is the only survivor of a huge number of timbered buildings that once lined Bayley Lane. An engraving of it was published in *A Series of Ornamental Gables* by Auguste Charles Pugin (1831). The engravings in that book were by his pupil Benjamin Ferrey (1810–80). The most famous member of the Pugin dynasty was Auguste's son, Augustus Welby Northmore Pugin (1812–52), whose son Edward Welby Pugin (1834–75) was associated with the Coventry architect James Murray (1831–63).

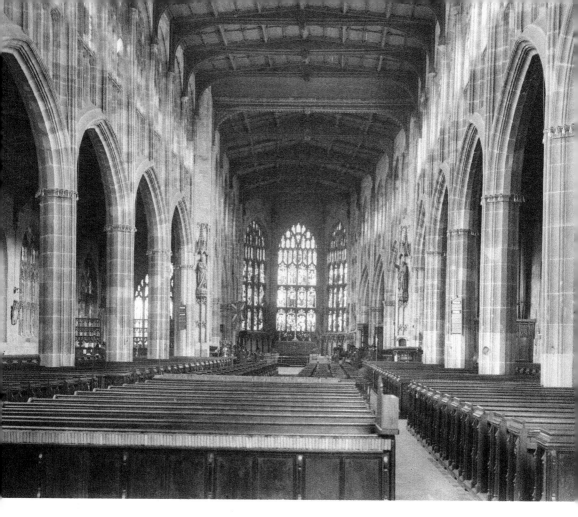

Above: Coventry Cathedral, 1925

The interior of St Michael and All Saints, originally the Church of St Michael in the Bailey, as it stood within the curtain wall of Coventry Castle. In 1918 it became a cathedral. This view, taken around 1925, looks down towards the apse with its great east window. It was built mainly at the expense of William, Adam, Ann and Mary Botoner in the fourteenth century and was destroyed by incendiary bombs in 1940. Interestingly, the adjoining Holy Trinity was relatively unscathed.

Opposite: Woolworths, 1935

F. W. Woolworths store on Smithford Street, photographed around 1935. Woolworth's was one of the first buildings to be built on the newly widened street. Woolworth's great boast of the time was 'Nothing over 6d.' This store was destroyed on 14–15 November 1940.

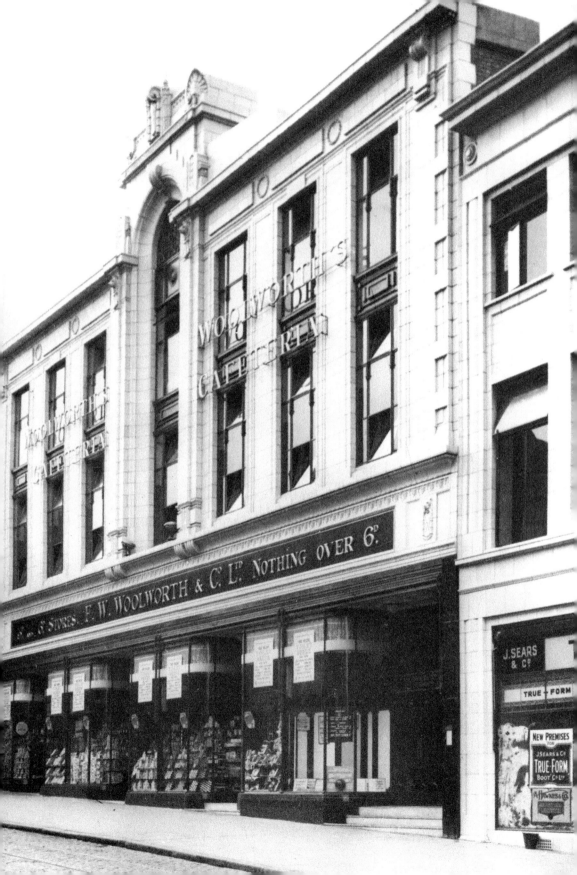

Old and New Broadgate and Precinct

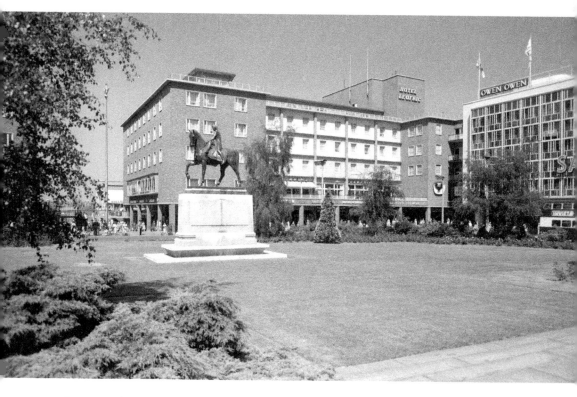

Above: Broadgate and Godiva, 1960
Broadgate and Godiva is photographed here around 1960. The statue of Lady Godiva, called *Self Sacrifice*, was unveiled in October 1949 and was sculpted by William Reid Dick. It was paid for by industrialist William Bassett-Green. Owen Owen department store on the right, designed by Coventry architects Hellberg & Harris, was built in 1953–54 and was the first post-war store built in the city. Behind is the Leofric Hotel and shops, opened in 1955.

Opposite above: Looking Towards Precinct, 1960
This image is looking up the new Upper Precinct towards St Michael's around 1960. Designed and built by city architect Donald Gibson, this was the first pedestrian precinct in Europe. Gibson left in 1955 and Arthur Ling took over, adding taller blocks of flats. At this time a much lighter railed bridge walkway than we have today can be seen joining the two sides. Some of the original blossom trees still stand here today.

Opposite below: Boy and stone, 1962
A fine photograph, taken around 1962 from the bridge walkway, showing a little boy looking at the Levelling Stone. This stone, unveiled 8 June 1946, marks the level and starting point of city centre redevelopment.

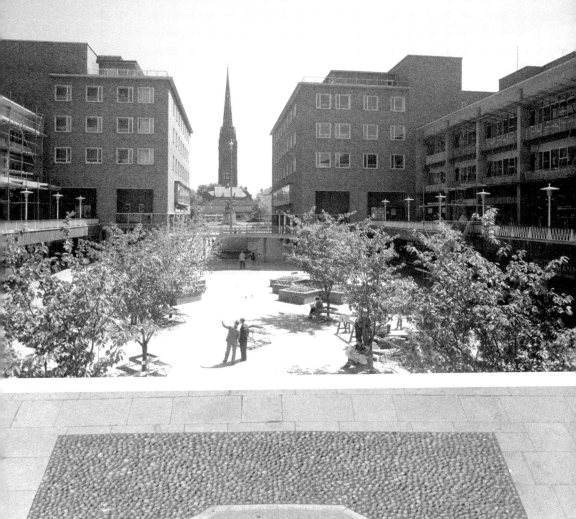
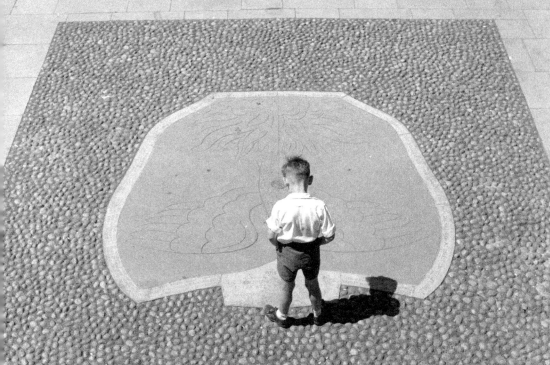

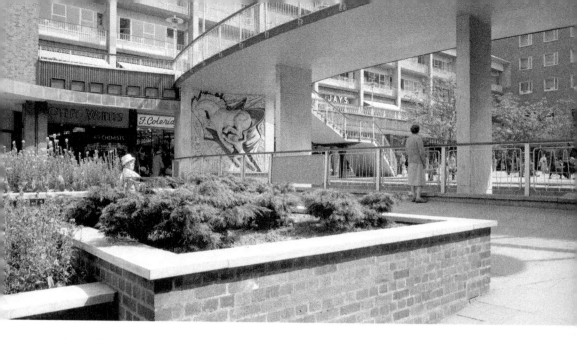

Above: Water Feature, 1960

The Upper Precinct water feature and original bridge next to Marks & Spencer in the lower part of the Upper Precinct is photographed here around 1960. Each end of the water feature was decorated with two amazing Portland stone panels carved by Coventry-born artist/sculptor Walter Ritchie, called *Man's Struggle*. The photograph shows man's struggle to control nature. They are now on the exterior of the Herbert Art Gallery and Museum.

Below: Flower Bed, 1960

A detail taken from the bridge over the water feature with two girls enjoying the sunshine and limelight. The flower beds stand before Marks & Spencer's store, which opened on the 2 April 1954.

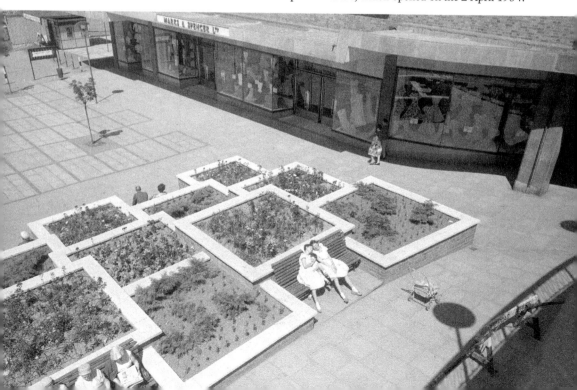

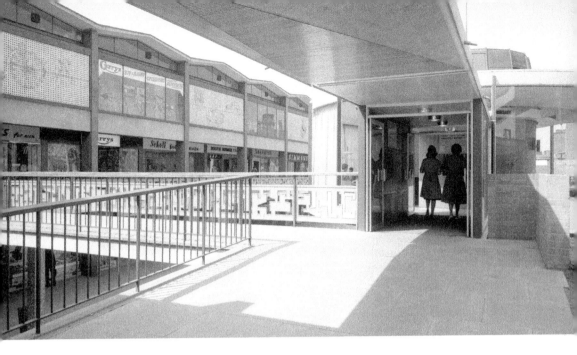

Above: Lower Precinct
This image is looking down into the Lower Precinct in 1960. Two ladies enter the round café designed by the Coventry City Architects department and opened in 1958. The Lower Precinct was designed by Arthur Ling and built by Coventry Council. Ling learned from Gibson's design of the Upper Precinct that the split levels didn't work via stairs and instead used ramps, making it more accessible. Despite many rumours over the years, the round café never rotated.

Below: Tiled Panel Artwork, Lower Precinct
A walkway in the Lower Precinct showing a section of tiled panel artwork by Gordon Cullen depicting the history of Coventry from prehistoric times. This section still exists, but has been moved a short distance from its original location.

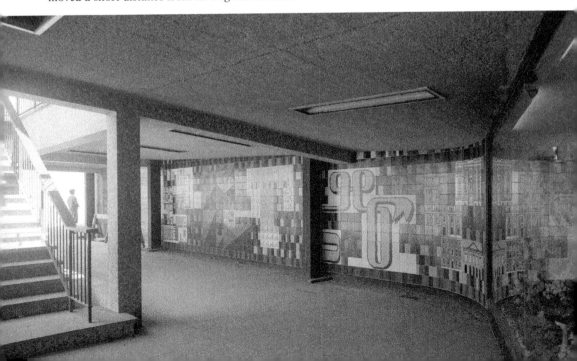

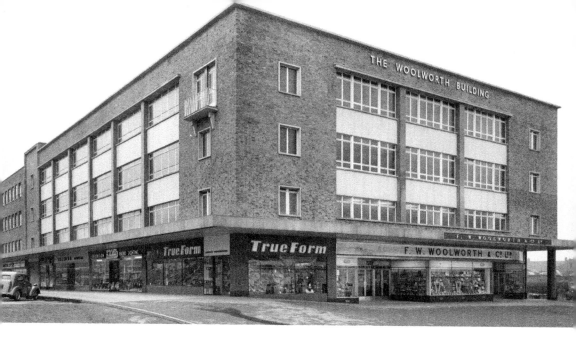

F. W. Woolworth's

Completed in 1954, the first building at the entrance to the Lower Precinct was the F. W. Woolworth's store, which originally ran the whole length of the first block down Market Way. For many years this was one of Coventry's favourite stores and seemed to sell everything until, sadly, it closed in January 2009.

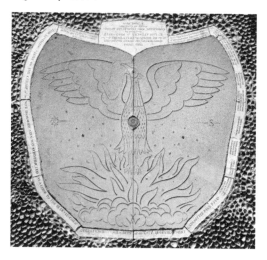

Levelling Stone

Coventry's Levelling Stone showing the phoenix rising from the flames. It is formed by an irregular slab of Cumbrian slate with a bronze plate at its centre, and marks the compass points west, south and east with a sunburst marking the north. City architect Donald Gibson drove to a quarry in the Lake District to personally order this piece of Cumberland granite. On it, the phoenix holds a scroll in its beak bearing the plans of the new precinct. Unveiled in June 1946, it originally sat at a lower level and was raised to pavement level in 1956. It was recut in 1975 as it was becoming worn. The stone was intended to mark the redevelopment of Coventry. Below it lays a buried casket containing records of the Blitz and plans for rebuilding.

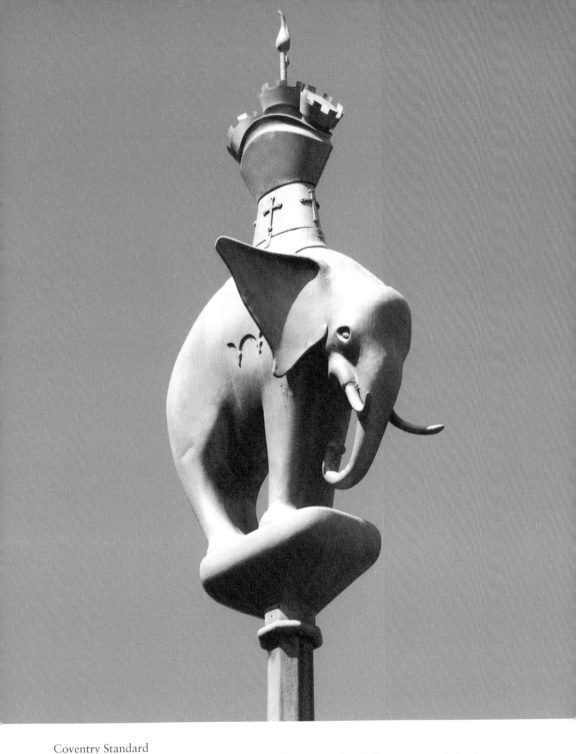

Coventry Standard

Known as the Coventry Standard and erected in 1948, the 56-foot mast made by Armstrong Whitworth bears Coventry's elephant and castle (from Coventry's coat of arms), 5 feet high and made by Motor Panels. This was the first object erected in Broadgate and flags originally flew from its yard arms. It became a well-known meeting place in Coventry – 'under the elephant'.

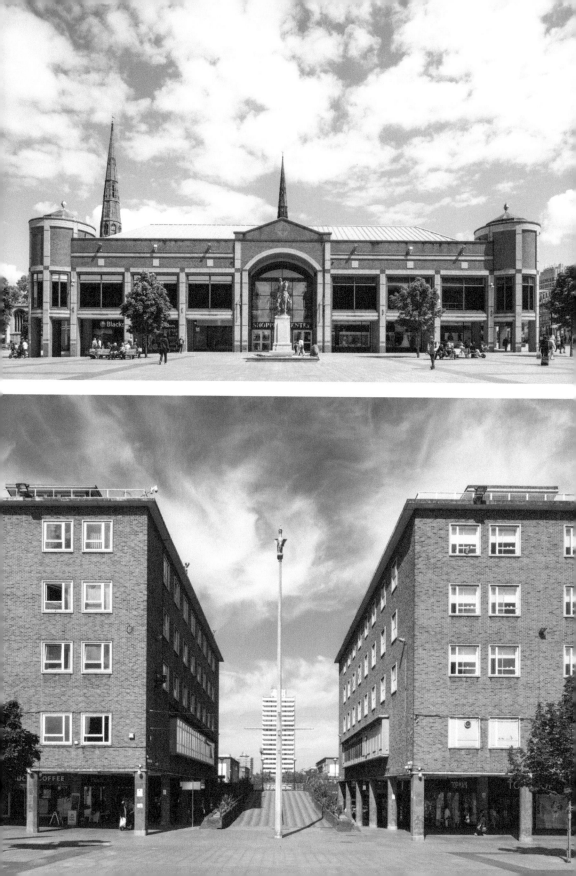

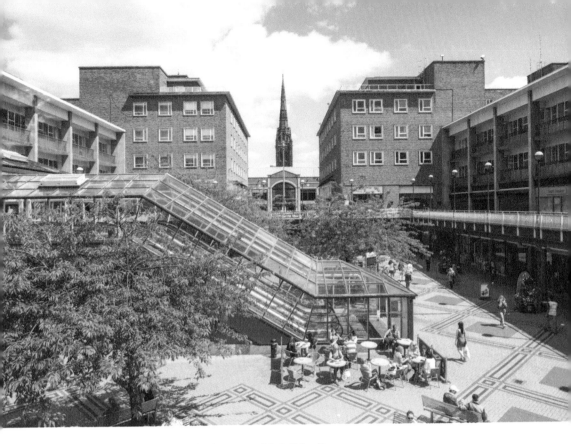

Above: Upper Precinct Towards the Spire of St Michael's

This image shows the Upper Precinct in 2014 looking towards the spire of St Michael's. Designed by Donald Gibson in a style reminiscent of the Festival of Britain, Gibson styled it on the two-tiered Rows in Chester, but the upper section has never been adequately used.

Opposite above: Cathedral Lanes, 2014

Cathedral Lanes is photographed here in 2014 after the removal of the tent that had covered the Godiva statue and was very unpopular with some people. Cathedral Lanes opened in 1990, originally with smaller units to encourage a variety of traders. The building has been changed over the years to accommodate Wilkinson's and lately to house a range of restaurant outlets. More outlets are to be added to the restaurant quarter in 2017.

Opposite below: Upper Precinct

A photograph taken in 2014 looking from Broadgate into the Upper Precinct. On the left stands Broadgate House, which opened in 1953. Designed by Donald Gibson and built on council land at a cost of £400,000, the building houses shops and still contains council offices. On the right stands Gibson's section of the Hotel Leofric building.

Homes

Above: Homes and Workshops
These are homes and a factory built by the Cash family in Kingfield in 1857. They comprised of cottages for the weavers' accommodation, and a top room with a loom powered by a steam engine housed at the end of the block. Designed by Coventry architect James Murray, these homes/workshops later had their workshops separated from their cottages. Cash's still produce bookmarks and cards, and many people will remember them for the name tapes used in school uniforms.

Opposite: St Michael's House
Coventry homes come in all shapes and sizes; this was once one of the city's most beautiful homes, St Michael's House, No. 11 Priory Row. Originally called 'The Priory', it was built by David Wells and was completed in 1741. Wells' occupation as a wine cooper is reflected in the skilful wrought ironwork, which includes grapevines and leopards – symbols of Dionysus and Bacchus, the gods of wine.

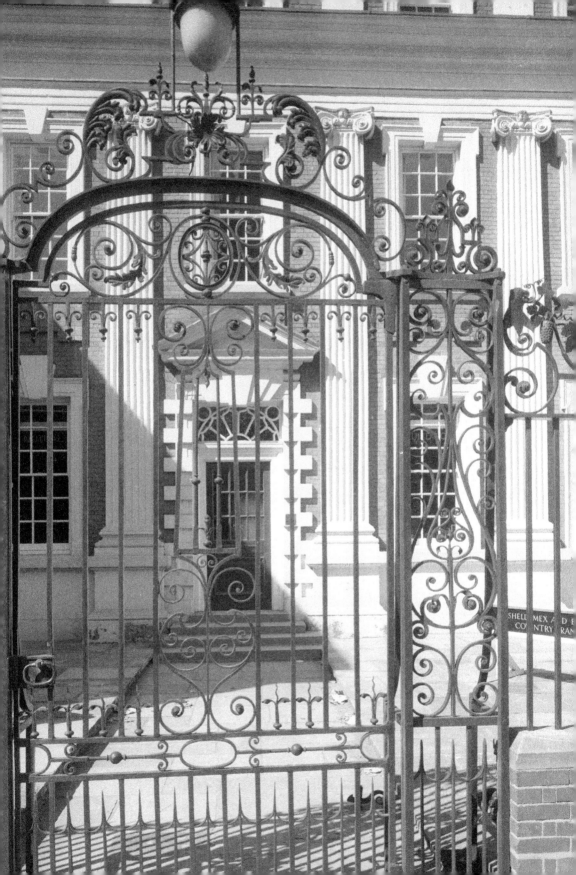

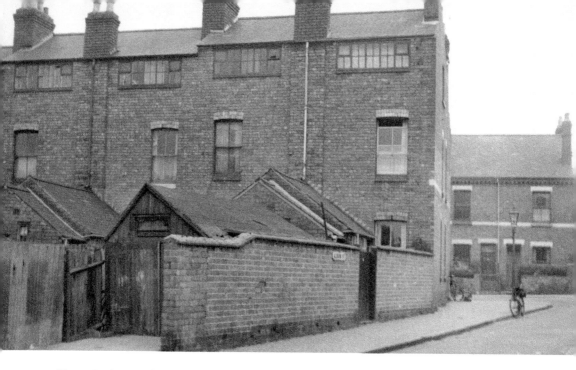

Above: Rudge Road

Once a common sight in parts of Coventry, this image shows watchmakers' or ribbon weavers' homes and workshops, 'top shops', in Rudge Road, photographed in 1953. This road, named after the nearby Rudge cycle factory, was demolished for the ring road.

Below: Watchmakers' Homes and Workshops, Norfolk Street

Mid-nineteenth-century watchmakers' homes and workshops in Norfolk Street in 1954. Bahne Bonniksen, a Dane, was one of the best-known watchmakers on Norfolk Street. He invented the 'Karussel escarpment'. One of his watches was on the ship that took Amundsen to the South Pole. Surviving workshops in Norfolk Street are now Grade II listed as they contain some of the best-preserved workshops in the city.

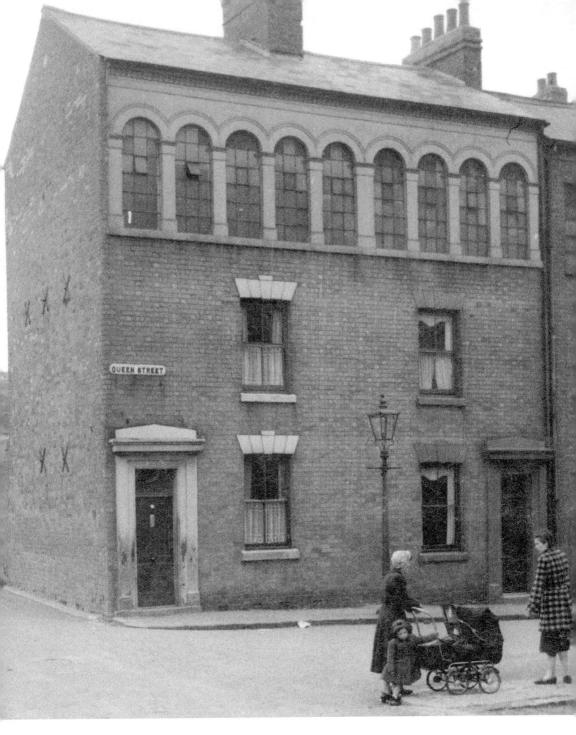

Watchmakers' Homes and Workshops, Queen Street

Rather fine-looking watchmakers' houses and workshops in Queen Street, Hillfields, photographed in 1953 and later demolished. These are unusual because they have beautiful windows rather than the large square windows found in most top shops. In 1881 Edward Duggins lived in Queen Street. He was a watch finisher who checked and regulated watches – an important part of the watch's final production. Hillfields was also home to many weavers.

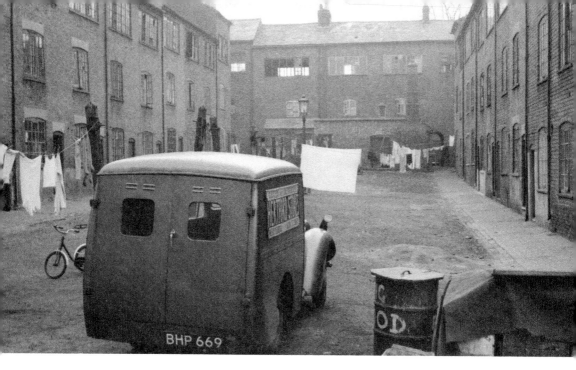

Above: Coventry Court

A view of a Coventry court, described on the original 1953 photograph as 'Hertford Place, Albion Street, Weavers Court'. This is one of the larger city courts. There was once literally hundreds around the city, but many were much smaller and narrower than this court. Despite the abundance of these courts, no complete examples survive today.

Below: Top Shops, Albert Street

Taken in Albert Street, Hillfields, in 1954, this photograph shows yet more top shops, presumably for weavers. Although Albert Street has survived, no old buildings survive on it. Like much of old Hillfields, they were demolished in the 1960s and '70s.

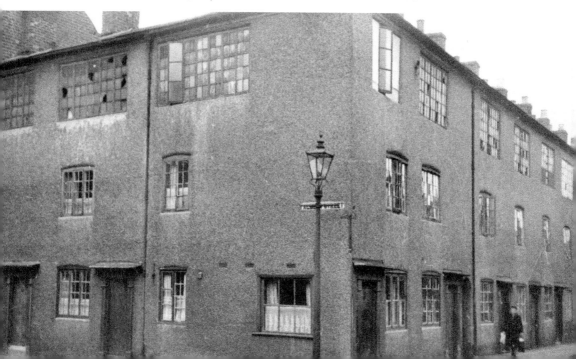

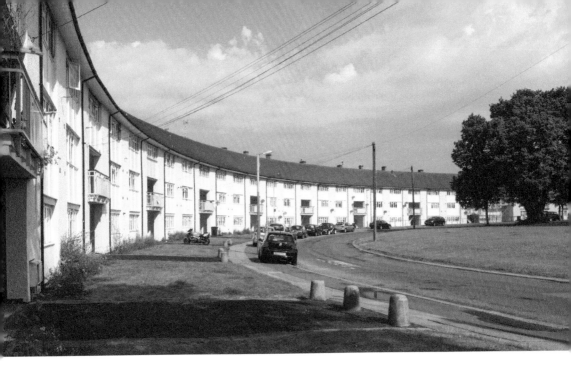

Above: Jardine Crescent, Tile Hill
Bath or Coventry? A crescent of homes in Jardine Crescent, Tile Hill, photographed in 2014. The crescent is named after Dan Jardine, who was the site foreman of the building of the Tile Hill estate. The crescent is locally known as 'the banana'.

Below: Wellington Gardens
This image shows post-war prefabricated homes in Wellington Gardens, Spon End. The area these homes were built on was originally part of the gardens and bowling green attached to the Bowling Green Inn, which was originally the Victoria Vaults in 1829. Wellington Gardens was an early 1950s development of old peoples' housing, shops and community buildings set within a landscaped area and designed by Donald Gibson.

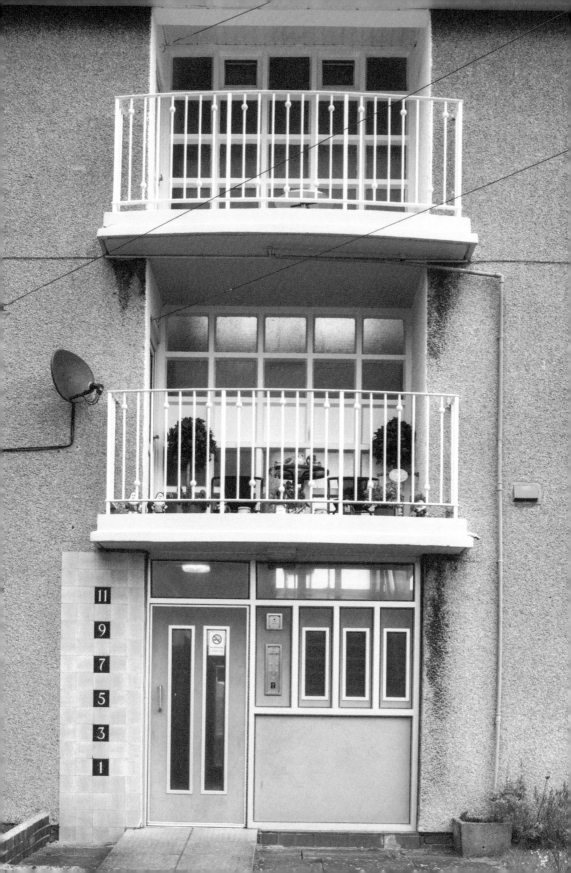

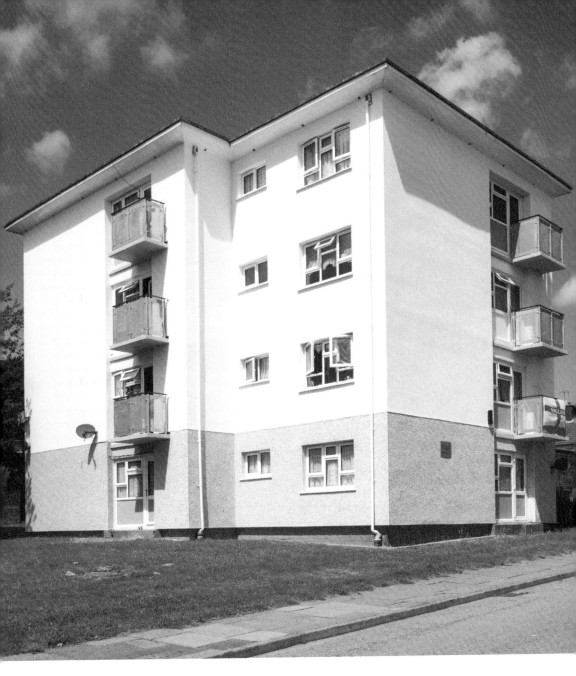

Above: Flats, Aldrich Avenue
A block of flats in Aldrich Avenue, Tile Hill, dating from the 1950s and photographed in 2014. There are a number of these types of flats spread around the city – functional but of an interesting design.

Opposite: Gregory Hood Road
The entrance to flats and upper stairwell lights in Gregory Hood Road, Stivichall, photographed in 2014. The road takes its name from the Gregory-Hood family who owned Stivichall Hall and estate until its sale in 1932.

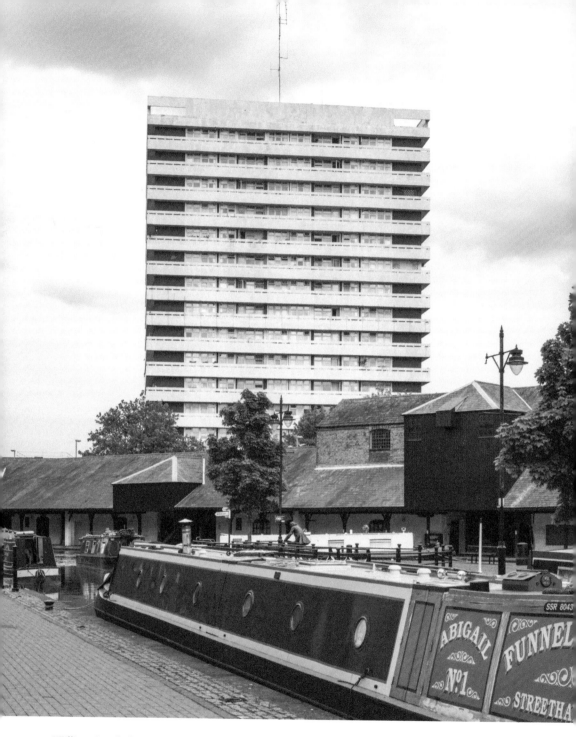

William Batchelor House

Two types of radically different homes in one photograph. In the foreground the home of a non-Coventry resident, a barge in the canal basin. Behind stands William Batchelor House, named after William Henry Batchelor, mayor of Coventry in 1930. The seventeen-storey tower block, built by Coventry City Council, is now managed by Whitefriars Housing.

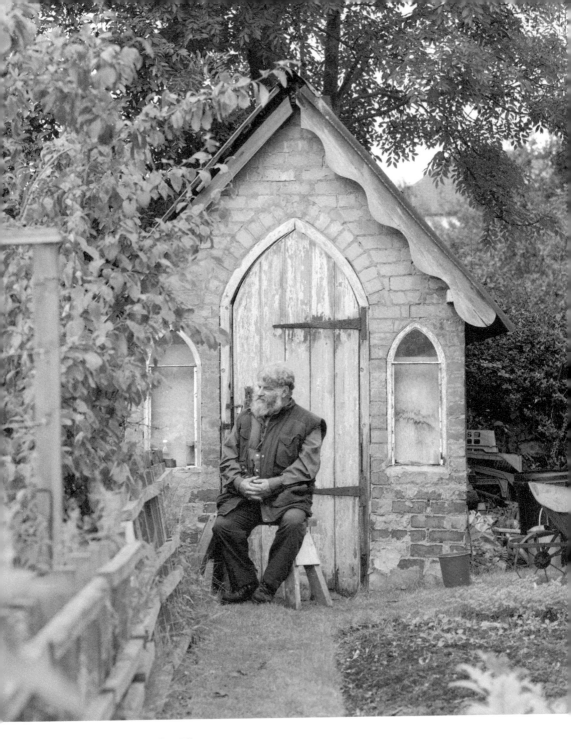

Brick Shed, Park Garden Allotments

Not quite a house, but one could say a home from home, this image shows a rather handsome Victorian brick shed in Park Garden allotments in Stoney Road, Cheylesmore, photographed in 2003. Cheylesmore Park had a number of allotment gardens cultivated in 1870. In 1935 the council acquired these gardens, known as the Cheylesmore Estate allotments, and they remain in use today.

The Cathedral and Churches

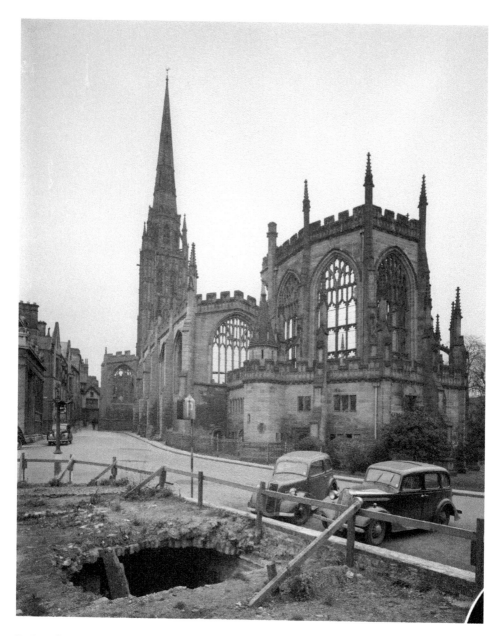

Ruins of St Michael's
The ruins of St Michael's, the second cathedral, taken on 10 April 1946. This fine building was burnt down by incendiary bombs on the night of the 14–15 November 1940. The ancient Bayley Lane was destroyed and the hole in the foreground is the fourteenth-century cellar, which is still accessible through the Herbert Art Gallery and Museum.

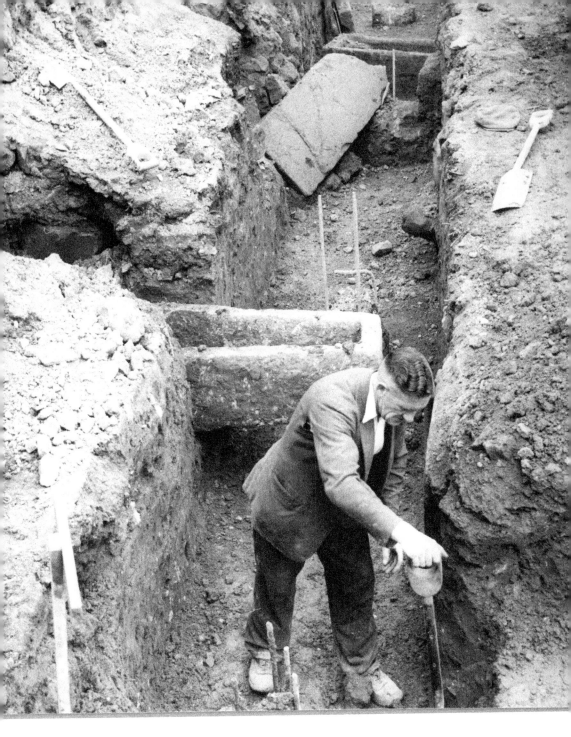

Robing Room Foundations

Digging the foundations of the Robing Room and choir practice room of the new cathedral on 10 May 1955. Note the remains of two stone twelfth- to fifteenth-century coffins made for notable individuals. Hundreds of objects were unearthed during construction from Roman to modern times, but sadly little was recorded.

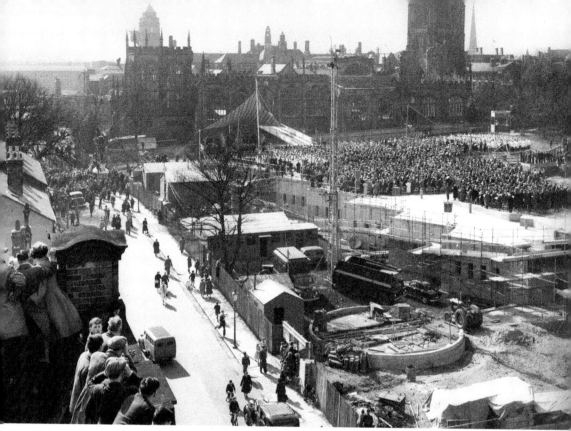

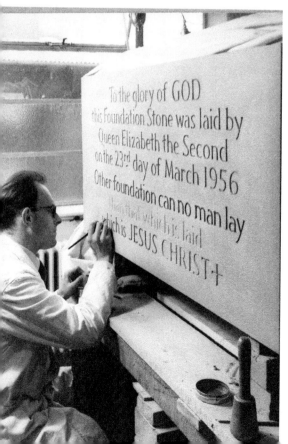

Above: Laying of the Foundation Stone
A view taken from a nearby building showing the 3,000-strong crowd gathered at the ceremony of the laying of the foundation stone on 23 March 1956. The stone was laid by Her Majesty the Queen, accompanied by Prince Philip.

Left: Carving the Foundation Stone
The German former internee Ralph Beyer carving the foundation stone of the new cathedral in March 1956. At the bottom it reads, 'Other foundation can no man lay than that which is laid which is JESUS CHRIST.' Beyer did many beautiful carvings in the cathedral including 'The Tablets of the Word' set into the cathedral walls.

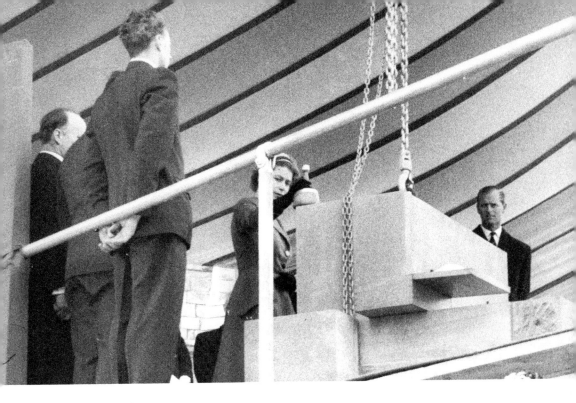

Above: Laying Ceremony

Detail of the actual laying ceremony performed by the Queen. The Queen and Prince Philip stood by the King's Pinnacle in the ruins and walked to the foundation stone of the new cathedral while the bells in the old tower pealed. Her Majesty tapped the stone with a silver mallet and said, 'I declare this stone well and truly laid.'

Below: Window Arch

Dated 8 August 1957, but probably earlier than this, a group of boy scouts look through a window arch at the growing building. This was the window Basil Spence said he looked through, where he saw a vision of the new cathedral with its huge and decorated window and tapestry. This window was made into an entrance to the 'Queen's Way'.

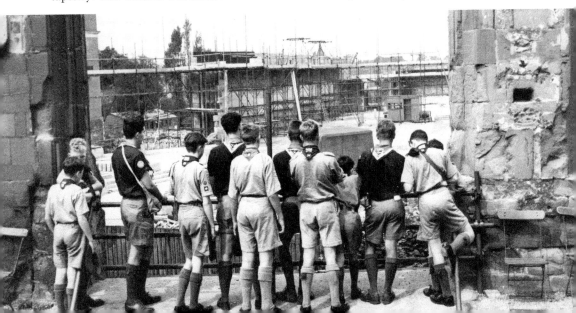

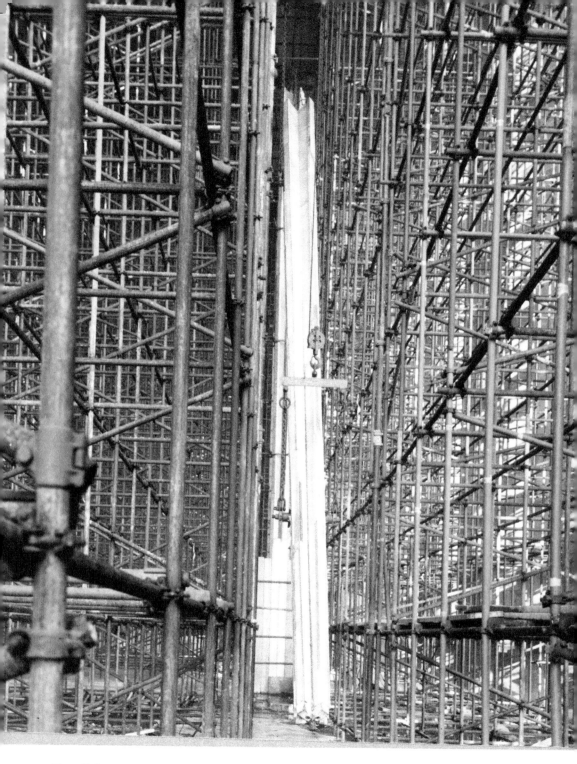

Nave Column
View of a nave column being hoisted into position in the growing cathedral amid a sea of scaffolding, taken in 1958.

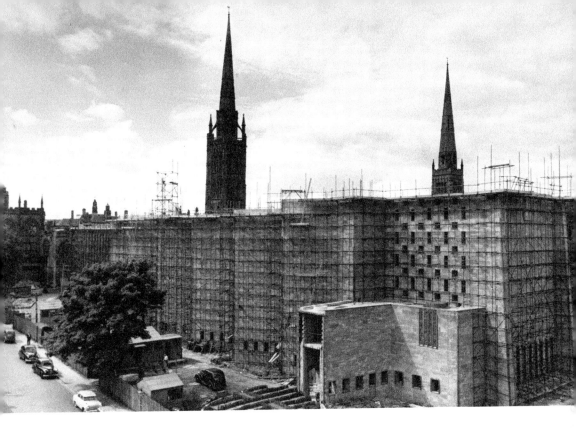

Above: The Buildings Grows
A photograph taken on 6 August 1958 showing how the building was being expanded. Basil Spence was influenced by massive Norman walls on cathedrals such as Durham.

Below: Golden Cross, Chapel of Christ the Servant
Men positioning the golden cross on the roof of the Chapel of Christ the Servant. The Lanchester Polytechnic can be seen in the background.

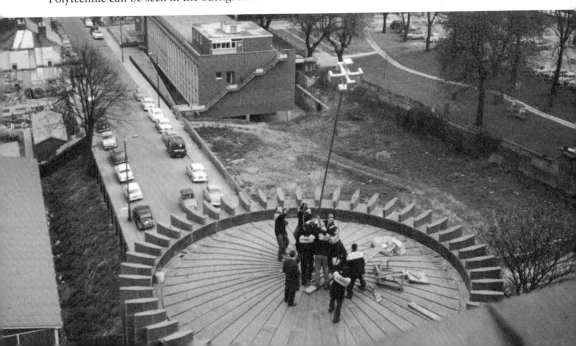

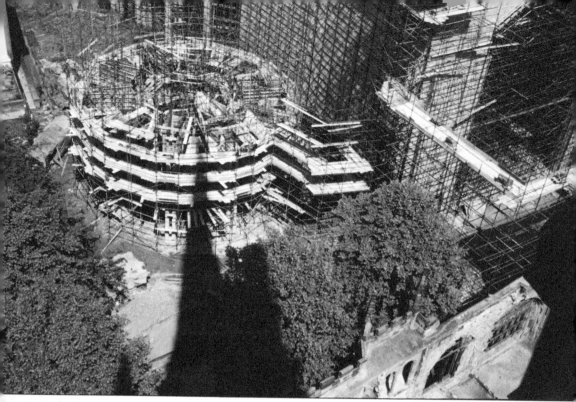

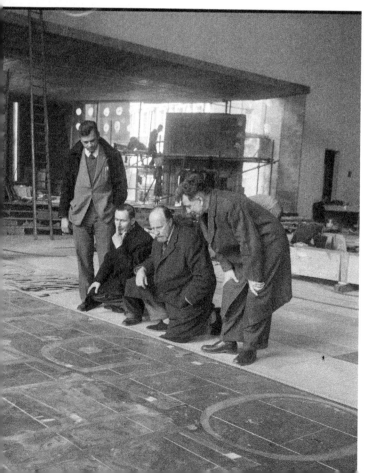

Above: Chapel of Unity
The construction of the Chapel of Unity. No. 11 Priory Row stands on the left and to the right of that, touching the new cathedral, the apse of St Mary's Cathedral Church was unearthed showing three cathedrals on adjoining sites. The chapel was based, it is said, on a crusader's tent.

Left: Sir Basil Spence
Taken on the 8 March 1962, this image shows Sir Basil Spence (second from the right) kneeling with Ralph Beyer inspecting the incisions for Beyer's metal-inlaid lettering under the West Window. Spence is said to have remarked that most people hated his cathedral. After its completion, work dried up and he nearly went bankrupt. It was voted Britain's best-loved building in 1999.

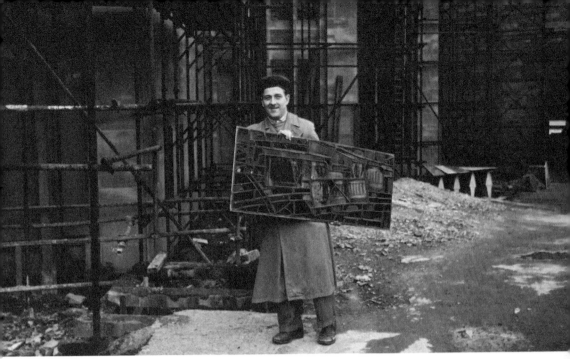

Above: Stained Glass
A workman holding a piece of
stained glass made by Patrick
Reyntiens ready to place in the
Baptistery window designed
by John Piper. This is one of
195 panels that made up the
window representing God's
light projecting into the world.

Right: 'Christ in Glory in the
Tetramorph'
Taken on the 7 March 1962,
this photograph shows
the hanging of the largest
tapestry in the world, known
as 'Christ in Glory in the
Tetramorph'. It depicts Christ
seated surrounded by the four
evangelists with mankind
represented by one life-size
man standing between his
feet. Designed by Graham
Sutherland, it measures 74 feet
8 inches by 38 feet.

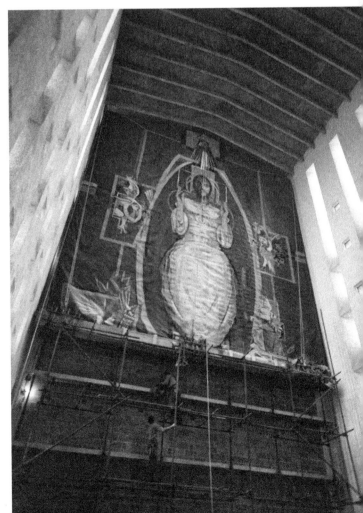

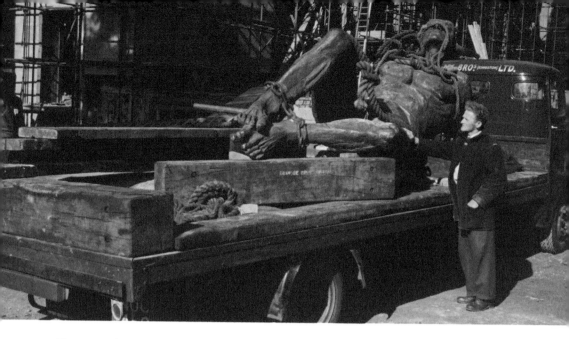

Above: Jacob Epstein's Devil

An amazing picture showing Jacob Epstein's Devil on the back of a lorry ready to be placed on the building. The idea of St Michael and the Devil was down to Spence, who contacted Epstein in 1955 about its creation. Epstein was so taken with the idea that he started the work before official approval. He used an unknown athlete for the Devil's body, and used his daughter Kitty's husband Wynne Godley as model for the head of Michael. Epstein appears to have modelled the Devil's face on himself. The bronze was cast in 1958 and did a tour of Britain before finally arriving in Coventry in 1960 after Epstein's death.

Below: Devil

The Devil being hoisted up onto the wall of the cathedral. It has been pointed out in the past that the chain that Epstein has binding the Devil is not secure; this makes sense for if the Devil was permanently secured there would be no evil in the world.

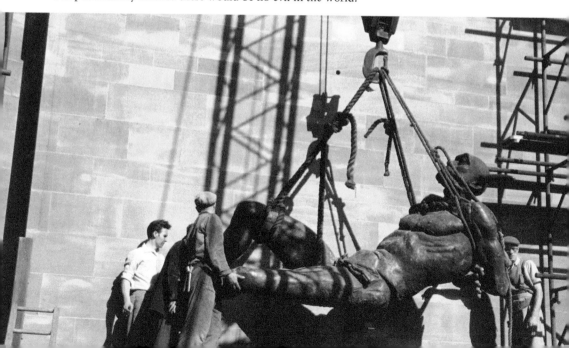

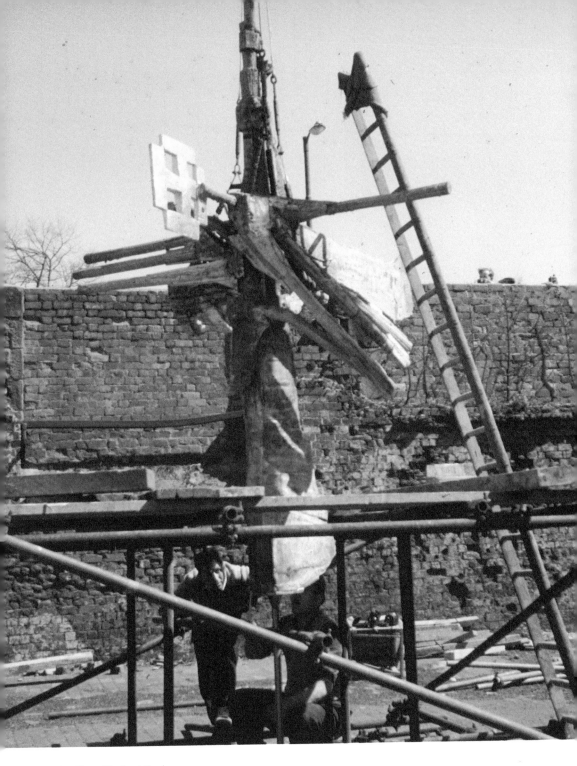

Geoffrey Clarkes' Sculpture

Taken in 1962, this image shows Geoffrey Clarkes' metal openwork fleche sculpture about to be lifted on to the cathedral roof. After being in place for some time the original was found to be too heavy and was replaced with a fibreglass copy.

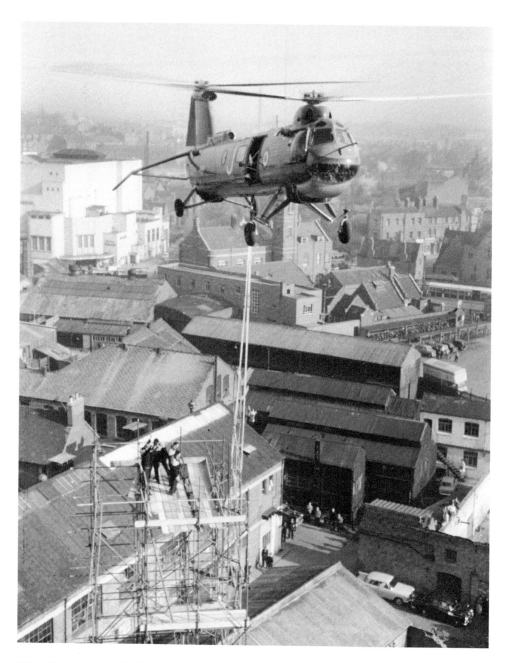

Wing Commander John Dowling
This image shows the 80-foot fleche being raised into the sky by a helicopter flown by Wing Commander John Dowling, known as Mr Helicopter for the dramatic rescues he made in the Malaysian and Borneo crisis of the 1950s and '60s. Dowling was chosen for his expertise as the tower section of the sculpture could easily pierce the roof and bring the ceiling down. This delicate operation of placing the sculpture on top was completed in forty-five minutes and was watched by thousands. It remains in the memory of many Coventrians.

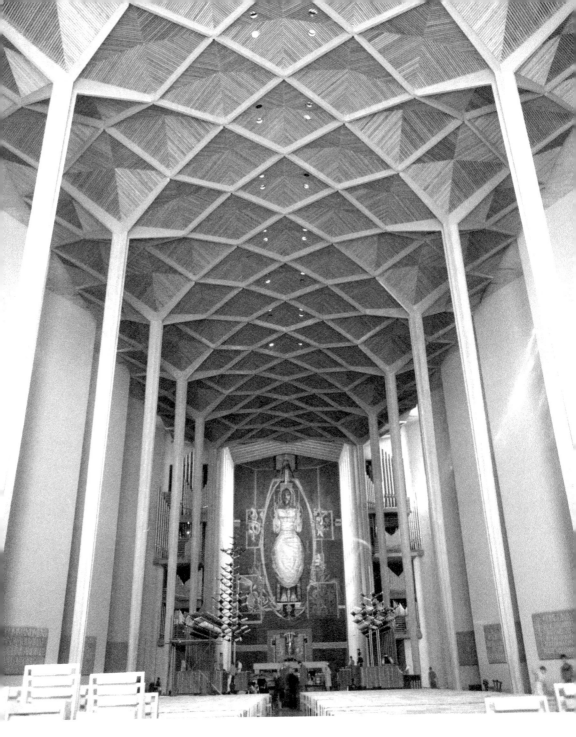

Towards the Tapestry

A beautiful picture looking down the nave towards the tapestry. The slender columns and fantastic roof are impressive, reminding one of a medieval church. The base of these tapered pillars have a tiny square set into the floor of the cathedral – originally Spence wanted to set them on glass balls! This was in Spence's own words, 'the great barn'.

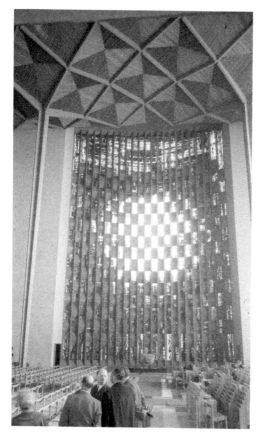

Baptistery Window
God's light filters into the darkness of the
world; a work of great beauty that changes
constantly with the light – here in black
and white. Its coloured stain glass is shown
on the earlier page.

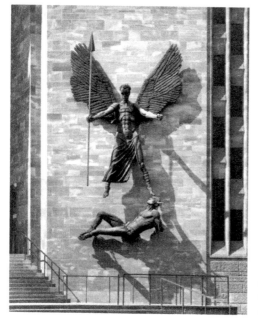

St Michael and the Devil
Sir Jacob Epstein's bronze sculpture
of St Michael and the Devil was unveiled
on the 24 June by his widow. Epstein
considered this his greatest work.

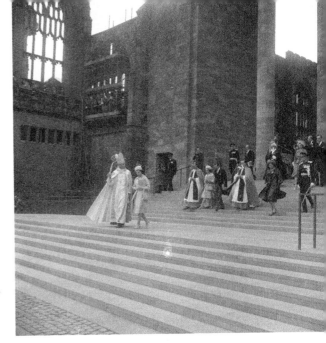

The Queen and Bishop of Coventry
The Queen leaving the cathedral after the consecration ceremony on the 25 May 1962. The queen is accompanied by the Bishop of Coventry, Cuthbert Bardesley, with Princess Margaret and Lord Snowdon following behind.

Church of St Francis
The original church of St Francis in Links Road, Radford, was started in June 1939 and badly damaged on the night of 14 November 1940. Thereafter services continued in a wooden hut built next door, which was burned down by an arsonist, so services were then continued in the Pilot Hotel. The second church was built in 1943 and the old one became a church hall and still stands. This photograph, taken in 2014, shows the interior of the second. Its foundation stone came from the old cathedral.

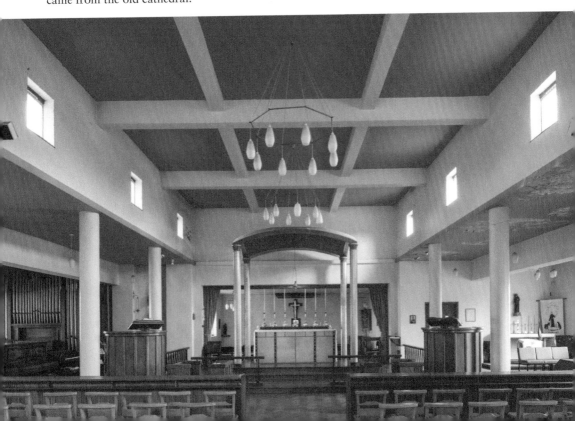

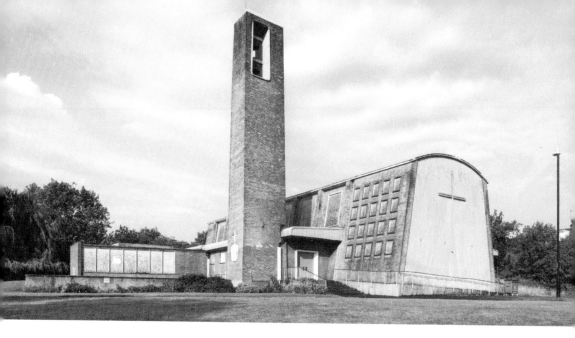

Above: Church of St Nicholas

The church of St Nicholas, Radford, was built to replace the pretty Victorian church destroyed by an air raid on 14 November 1940. This second church, a short distance away, was started in 1955 and is one of Coventry's most unusual churches. It was designed by Lavender, Percy and Twentyman. Its campanile carries two bells, which came from the original church. Sadly the church has been boarded up and the order for its demolition put forward in 2017.

Below: Christ Church, Cheylesmore

The interior of Christ Church in Cheylesmore, photographed in 2006. This interesting church was designed by Alfred Gardener in 1953. Its interior has been described as 'remarkable' and its vibrancy makes one think of a medieval painted church. This building, seemingly inspired by the style of the Festival of Britain, is considered a particularly complete example of its period.

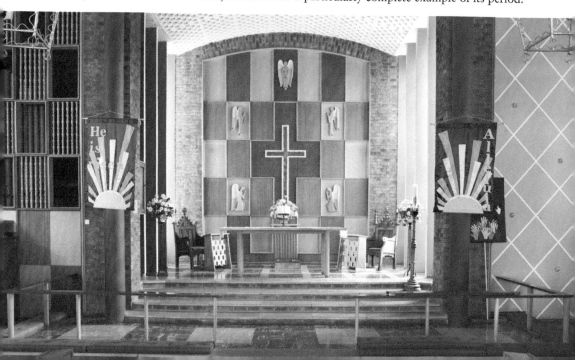

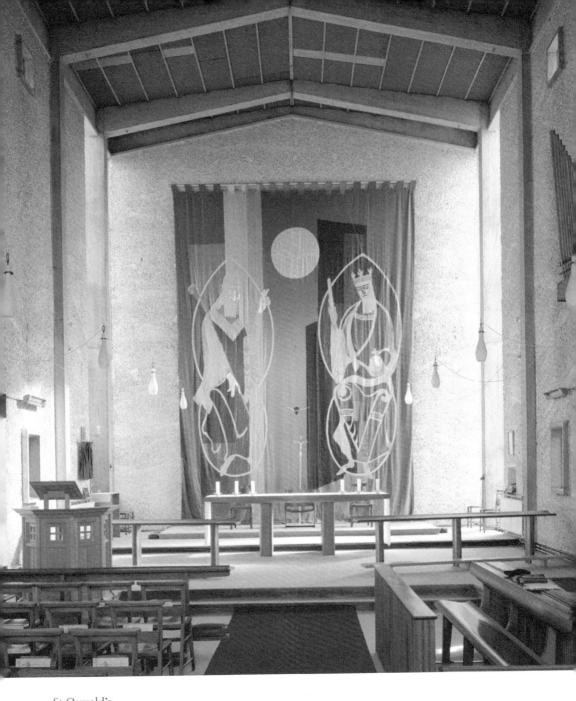

St Oswald's

St Oswald's in Tile Hill, photographed in 1992. The church and its bell tower were designed by Basil Spence, designer of Coventry Cathedral, and are considered remarkable for the fact that Spence used the new non-fines concrete construction method previously used by Wimpey to build houses. This church was also one of three new churches by Spence intended as trials for some of the features of the cathedral. All three churches are now listed buildings. Spence designed the altar, choir stalls and font and the communion set, and he employed other artists for various other items in the building, including the crucified Christ outside by Caroll Simms, who was apprenticed to Epstein.

Victorian Synagogue, Barras Lane
The Victorian Synagogue in Barras Lane, photographed in 2001. This beautiful Grade II-listed building was designed by Birmingham architect Thomas Naden in the Romanesque style and was opened in September 1870. The first official words spoken as its door opened for the first time were 'Open to me the gates of Righteousness; I will enter them and praise the Lord.' It closed in 2003 and has since stood empty. Sadly this fine building is now suffering extensive dry rot in the basement.

Anglican Chapel
An older forgotten Coventry church photographed in 1880 set within the London Road Cemetery and unseen by most of the population. This is the Norman-style Anglican Chapel, built as part of the cemetery designed by Sir Joseph Paxton, builder of the Crystal Palace, assisted by John Robertson and G. H. Stokes. Built in 1847, this now little-used chapel feels like a real Norman church inside.

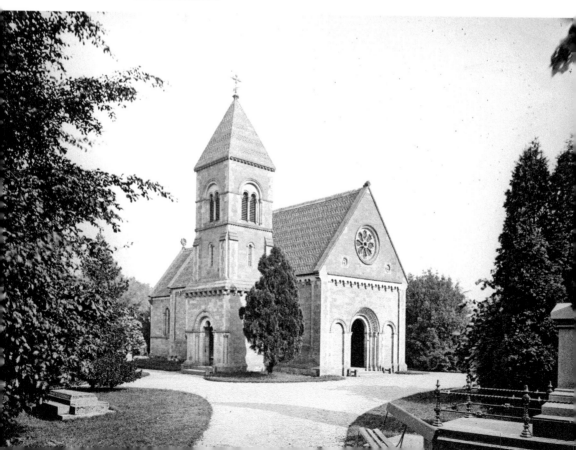

Buildings Old, New and Gone

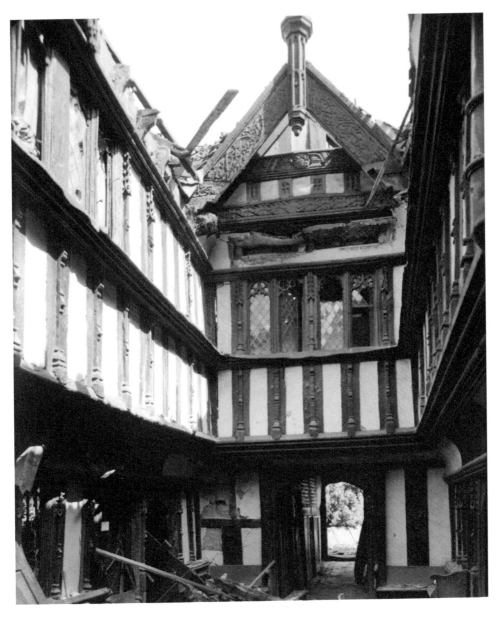

Ford's Hospital, 1941
Another view of Ford's Hospital, photographed in August 1941. It was hit by a bomb on 14 October 1940, killing eight inmates. The heavy oak timber absorbed much of the impact, helping it to survive. In 1941 the council planned to dismantle and resite it to accommodate Donald Gibson's plan to redesign the city centre. The building thankfully wasn't moved and was restored and reopened in 1953.

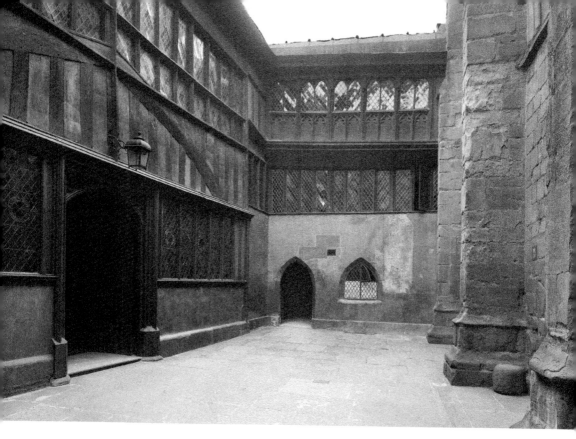

The Courtyard, St Mary's Hall

The courtyard of St Mary's Hall, photographed in 1917, was built on land given by Guy de Tilbrooke in 1340 and opened in 1342. This is considered the finest guildhall in England. The hall is entered on the left and the door ahead still leads into the kitchen. This courtyard was the starting point of practically every Godiva procession since 1678 when the son of James Swinnerton played the first Godiva. The stone on the right by the base of the buttress is called 'Lady Godiva's mounting block' as the Godiva's used it to mount their horses.

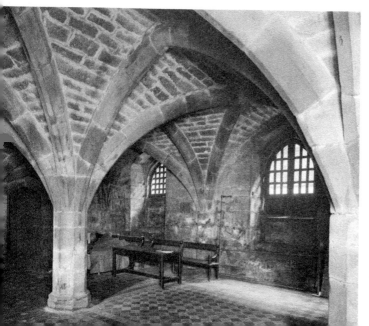

St Mary's Undercroft

This is an excellent shot of St Mary's Undercroft in 1917. Misnamed for many years as the 'crypt', the undercroft was storage space under the Great Hall. A merchant's mark is carved into the stone entrance, possibly of the Guild of St Mary – this mark is like the number four backwards with additional lines. The first builders of the hall later joined with other guilds, becoming the Guild of the Holy Trinity. This space in the past has been used to store cannon, shot and gunpowder, and arms.

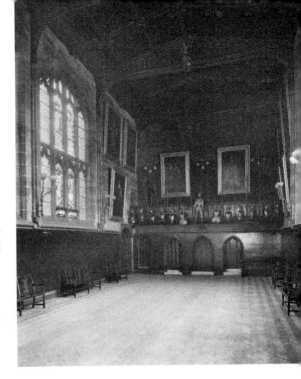

The Great Hall of St Mary's

The Great Hall of St Mary's looking south toward the Minstrel's Gallery, which has been decorated with armour since the nineteenth century. This photograph, taken in 1917, shows some differences between the hall today, as it then had more paintings and a herringbone floor. It still has a woodblock floor but the present one lies end to end. The hall then had its original blackened oak roof, which was damaged by incendiaries in April 1941. It was subsequently restored but was found to have death-watch beetle, so a copy was made. Luckily 95 per cent of the medieval roof bosses survived.

Prince's Chamber

The Prince's Chamber off the Great Hall in 1917. The room was named after the Black Prince, but was only given to the room around 1900. This was around the same time the Jacobean panels and fireplace were added, which came from the chemist shop of Mr Honeydew in the High Street. This room was used as a second council chamber and the town clerk's room; it was also home to the city archivist before the war.

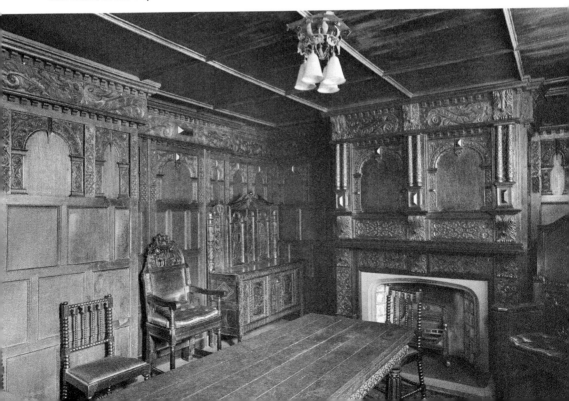

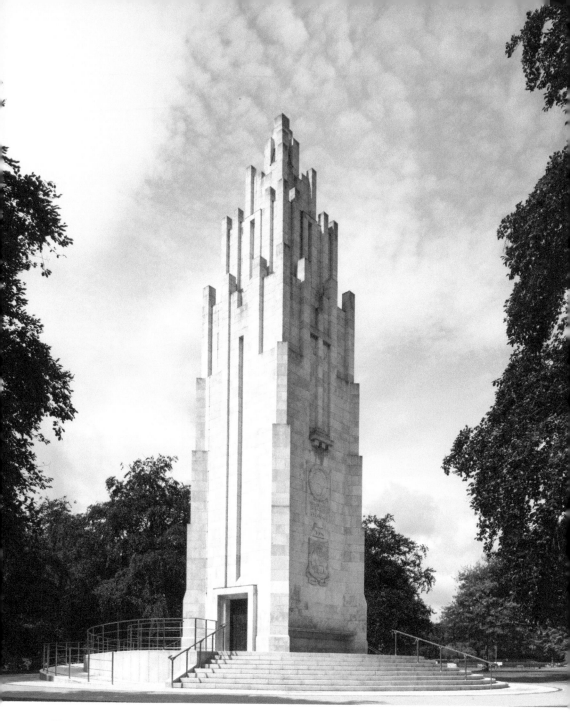

War Memorial

Not quite a building, but sort of, as it houses a chamber inside called the Chamber of Silence in which names of Coventry war dead are kept. This is the war memorial in the War Memorial Park. It was designed by Coventry architect Thomas Francis Tickner and unveiled by Field-Marshal Haig on the 8 October 1927. The ceremony, attended by Coventry VC holder Arthur Hutt, was witnessed by thousands and is still held annually.

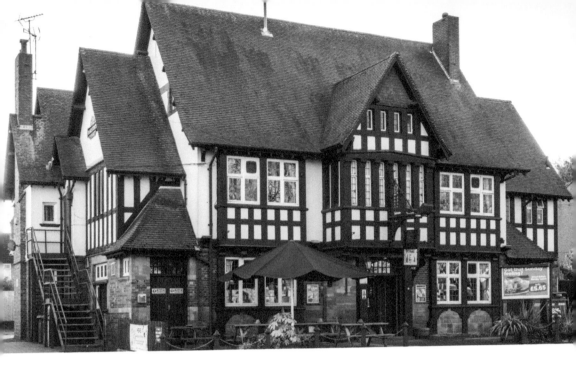

Above: Biggin Hall Hotel
The Biggin Hall Hotel on the Binley Road is the only twentieth-century Grade II-listed pub in Coventry. The hotel was designed in 1921 by Thomas Francis Tickner for brewers Marston, Thompson & Evershed and opened in 1923. It is built in what is known as the Brewers Tudor style and was listed because much of its original layout and fittings have survived.

Below: Lounge Bar, Biggin Hall Hotel
The lounge bar in the Biggin Hall Hotel has changed little since its opening. It is handsomely oak panelled and has a fine inglenook fireplace. All these original fittings, including many of the surviving tables, were supplied by Messrs Gaskell & Chambers Ltd of Birmingham in 1923.

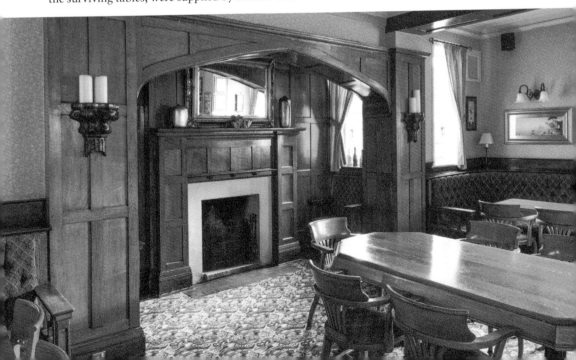

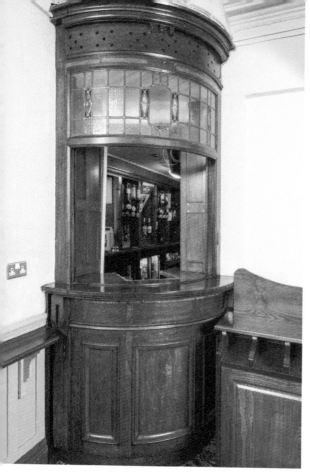

Left: Biggin Hotel
The curved serving hatch is a nice surviving detail in the Biggin between the two bars. The Triumph Recreation Ground once stood opposite with cricket pitch and tennis courts making it a popular pub.

Below: Flying Standard
The Flying Standard in Trinity Street began life in 1938 as the 'Priory Gate,' built over the entrance gatehouse to Coventry Priory. It was built to harmonise with adjoining Lych Gate cottages in Priory Row. Although this building has a steel frame, it uses much English oak, including carved bargeboards by woodcarver Louis Harvard. The building was built to fit within an oddly shaped plot and contains a few square rooms, with walls joining at acute angles. Used originally as individual shops, the building is now a Wetherspoon's pub.

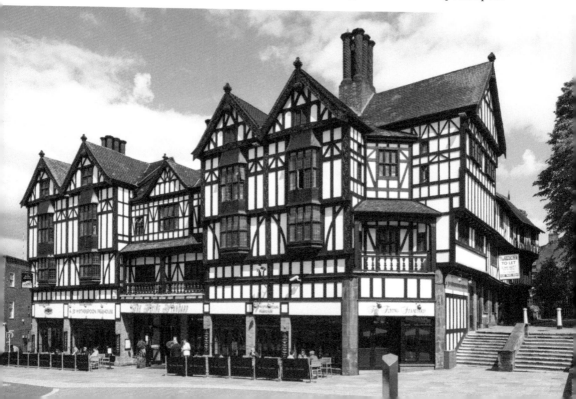

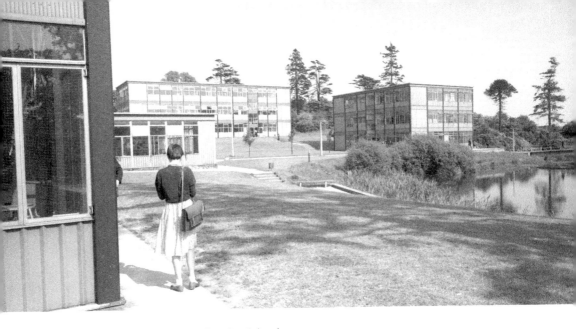

Above: Whitley Abbey Comprehensive School

Whitley Abbey Comprehensive School was built on the site of Whitley Abbey House and opened in 1955. It was formed by merging Churchfield High School and Cheylesmore Secondary Modern. The school was later demolished and replaced by Whitley Abbey Community School. Recently it was reopened by Princess Anne as the Whitley Academy.

Below: Belgrade Theatre

This image shows the main auditorium of the Belgrade Theatre in the early 1960s. The Belgrade was the first post-war theatre built in Britain. It opened in March 1958 and takes its name from Coventry's twin city, Belgrade – then in Yugoslavia. Beechwood donated by Belgrade after the war was used in parts of the building. The theatre was designed by Arthur Ling and cost £203,000.

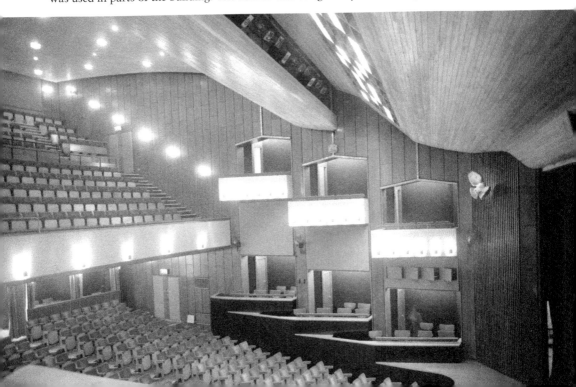

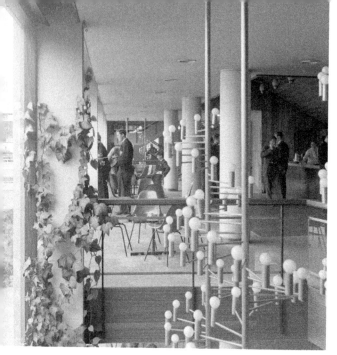

Belgrade Foyer
The foyer of the Belgrade in the 1960s showing the lights designed by German Bernard Shottlander as part of the council's policy of using German artworks in some public buildings. These lights were refurbished in the theatre's 2007 refurbishment and extension. The ground floor has a mosaic of the four seasons by Martin Foy. Originally laid out in a warehouse in London, it was numbered and relaid in the theatre in 1957. Like the lights, it has recently been refurbished.

The Herbert
Known these days simply as the Herbert, the Herbert Art Gallery and Museum in Bayley Lane was designed by architects Albert Herbert & Sons, cousin of Sir Alfred Herbert, who gave £200,000 for its construction. Sir Alfred laid the foundation stone in May 1954. Sir Alfred died in 1957 and the museum and gallery that bears his name was opened on 9 March 1960.

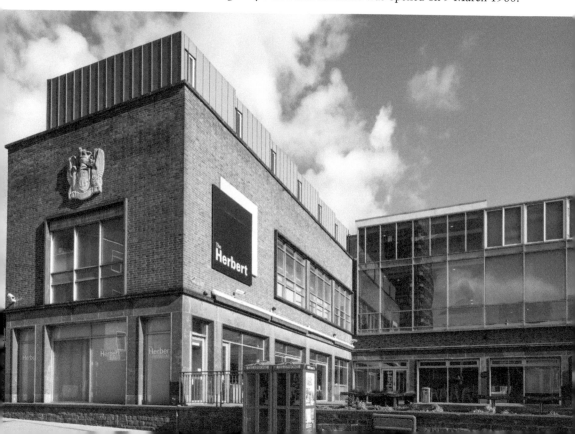

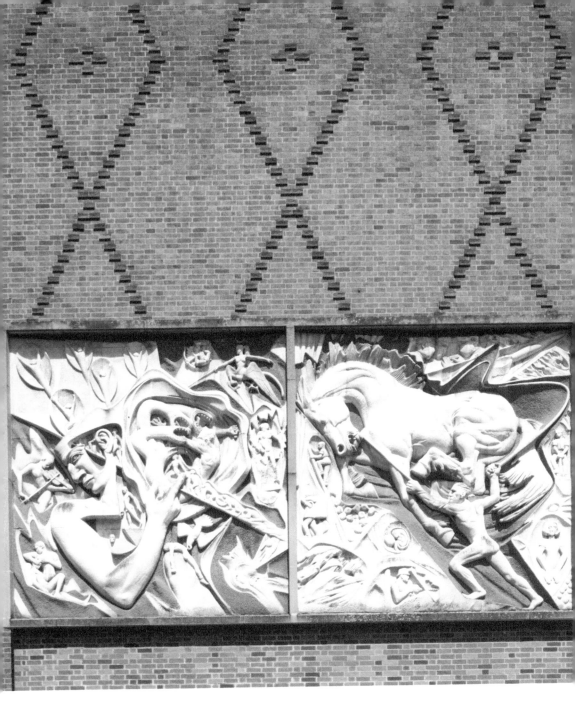

Herbert Facing Jordan Well

The side of the Herbert Art Gallery and Museum facing Jordan Well is shown here. The magnificent sculpture on it is by Walter Ritchie. Carved from Portland stone and started in 1954, it was unveiled in 1959. These sculptures originally formed the ends of the water feature that crossed the Upper Precinct by Marks & Spencer. Ritchie was born in Coventry in 1919. He was bombed out of his family home in 1940 and moved to Kenilworth, where he spent rest of his life. This fabulous work is called *Man's Struggle*.

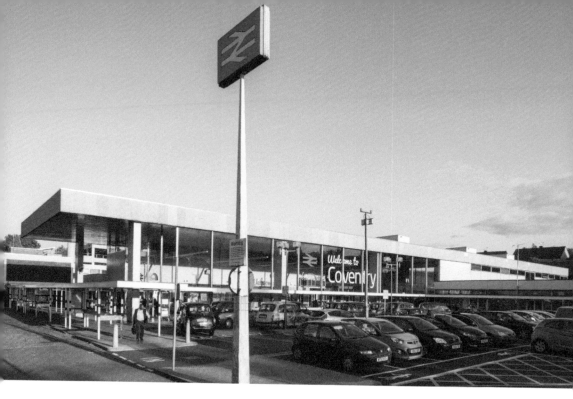

Coventry Railway Station

Coventry railway station from the north-west, taken in 2014. The original station was built in 1838. This was replaced in 1840, alterations were made in 1904, and in 1962 this station was built of concrete and glass. The station is Grade II listed. Nationally, few stations were built in this period and only a minority were of architectural merit.

Volgograd Place

An interesting photograph of Volgograd Place under the ring road – modern art and 1960s flyover together. Coventry's concrete ring road began with the Moat Street flyover and Ringway Rudge and Queen Road section in 1962. The second section, started in 1963, was Ringway St Nicolas and Foleshill Radial. Volgograd Place was named after Stalingrad. Coventry and Stalingrad/Volgograd were the world's first twin cities. The area was named in 1972 by Volograd's deputy mayor, Mikhail Zozotaryov, who came to the city on a peace mission. It is described in many Russian sources as a pleasant green space! Plaques here and the strange moonscape still commemorate the association.

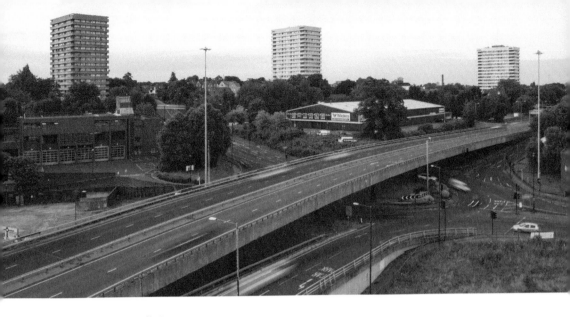

Above: Ringway Hill Cross
This section, called Ringway Hill Cross, up to the Radford Spur, was built in 1964. The ring road certainly cuts down traffic in the city centre, which is advantageous for locals but is a disadvantage for visitors unaware of its intricacies!

Below: Ringway Swanswell, Ringway Whitefriars and Leicester Radial
A photograph of Ringway Swanswell, Ringway Whitefriars and Leicester Radial constructed in 1968–69. The final section of the ring road was Ringway St Johns and Ringway St Patricks, constructed from 1971 to 1974. Unlike many ring roads around the country, Coventry's was actually completed. Birmingham's ring road was started and completed before Coventry's. Coventry's consists of more supported highways than Birmingham's, which is mainly ground level.

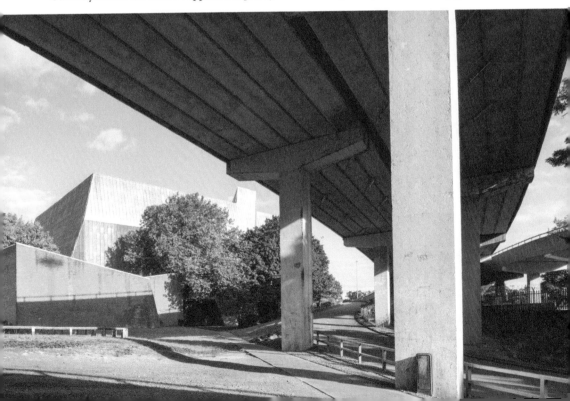

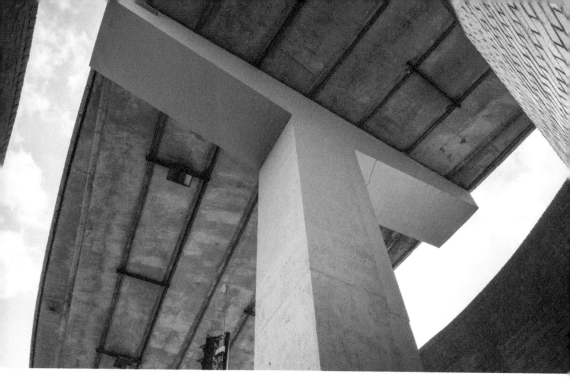

Above: Ringway Whitefriars
This detail of Ringway Whitefriars reminds one of a piece of modern artwork, although the impression is helped by the way the photograph is framed.

Below: Swimming Baths
Designed in 1956 by Arthur Ling, Terence Gregory and Michael McLellan, Coventry's iconic swimming baths was opened in 1966. The building was considered modestly priced at the time and was a high-quality build. The unusual 'W' roof is striking and the volume of glass makes the internal space feel well lit. The building is now Grade II listed.

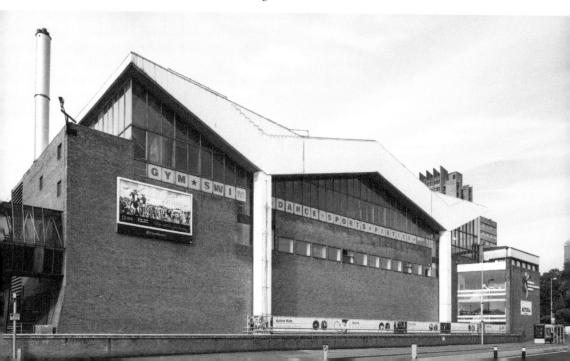

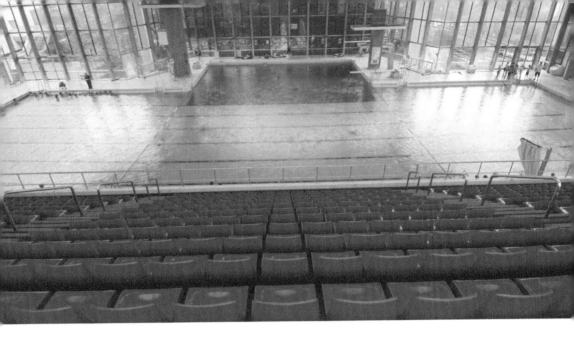

Above: Main Pool, Swimming Baths

This photograph shows the main 50-metre pool and seating for 1,174 people. The designers worked with the Amateur Swimming Association to create the perfect main pool. It was the only one in the West Midlands capable of hosting international events. The pool is actually no longer quite 50 metres in length, having been reduced in size when it was relined. The centre holds two other pools – for school and club swimming and for learners.

Below: Diving

Another internal view showing the separate diving area on the left. These swimming baths are being replaced by a new 'splash centre' in New Union Street with a pool half the original size, but it is hoped that Coventry University will make use of the old pool.

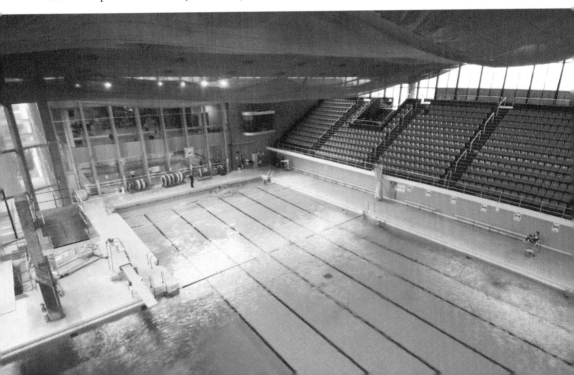

Above: Spon Street Townscape Scheme

The year after the opening of Coventry's grand swimming centre the ambitious Spon Street Townscape Scheme was launched. The scheme involved the renowned timber-framed building specialist Freddie Charles as architect, who brought his own philosophy to the modernist agenda. The first building restored in situ in 1969 was No. 169. This was followed by the first relocated building, No. 9 (previously No. 7) Much Park Street. Work continued, including the moving of the Green Dragon Inn, made famous by George Eliot's *Middlemarch*. This was moved from Much Park Street. The mid-fifteenth-century building is now Nos 20–21 Spon Street. By the end of the scheme in 1990 twelve buildings had been restored in situ and ten re-erected from other sites. The street now contains more Wealden houses than any street in England.

Below: Elephant Building

The locally famous elephant building, part of Coventry's swimming and sports complex, was opened in 1977. The zinc-panelled building was built by the City Council. The Coventry Society tried to get the building listed to ensure its long-term survival, but failed.

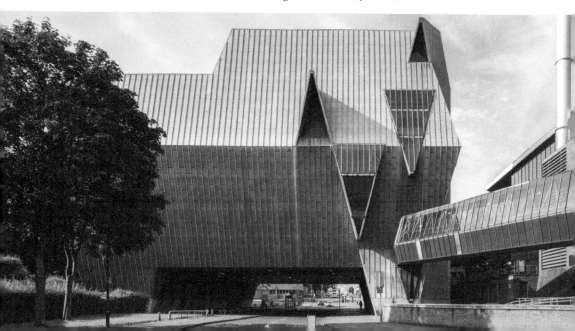

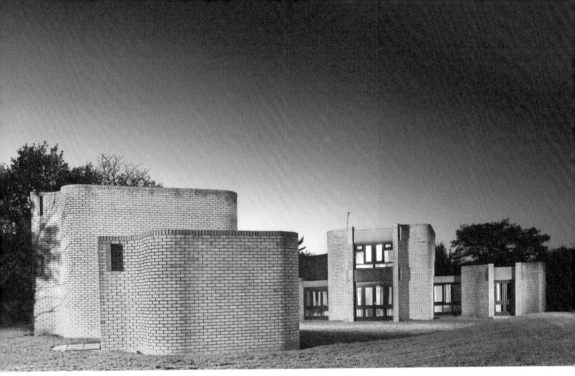

Above: Mathematicians' House
The Mathematicians' House at Coventry University resembles the remains of a ruined medieval castle. Built to house visiting mathematicians, this unusual and quirky building is certainly interesting. The house actually consists of five houses and two flats and was built in 1968–69 to the design of architect Bill Howell. This Grade II-listed building has curved walls in bedrooms and studies covered by blackboards for the visiting mathematicians to do what they do!

Right: The Hub
Old and new reflected in 'The Hub' of Coventry University showing the tower of St Michael's in the background. The Hub is the centre of the university with a coffee shop, bar, restaurants and supermarket. It also houses a medical centre, faith centre, a studio, a careers advice centre, enterprise advice and student union centre.

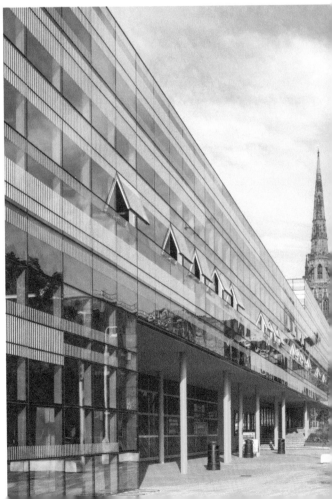

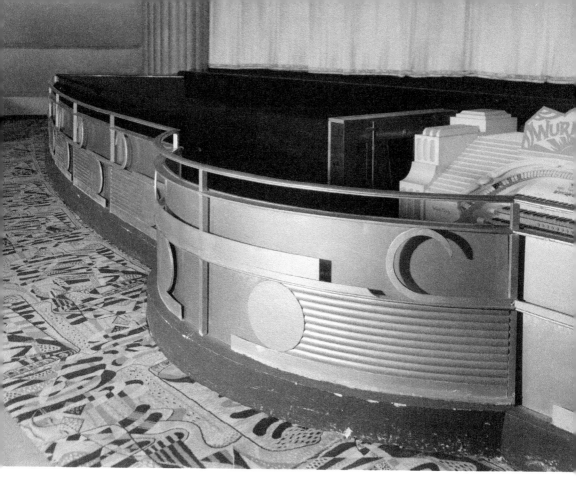

Rex Cinema

In contrast we now look at things gone or going. This photograph is one of the few surviving interior details of the Rex Cinema, Corporation Street. This showcase art deco cinema was built in 1936 and suffered bomb damage on 25 August 1940 – the day before it was scheduled to play *Gone with the Wind*. The photo shows the orchestra pit taken around 1936; this area was obliterated by the bomb.

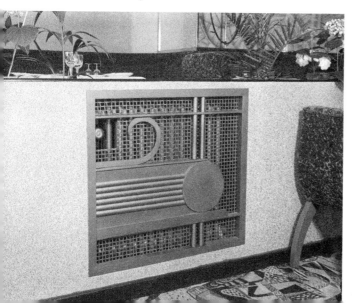

Art Deco Cafeteria

A detail taken at the same time of the art deco metalwork in the cafeteria. Near this area stood an aviary filled with exotic birds. The day after its destruction it was written, 'A dozen birds, some of them tropical, sat on their perches in the café ... of the wrecked cinema. The glass of their aviary had been blown away, but the birds had ignored their chance to escape...'

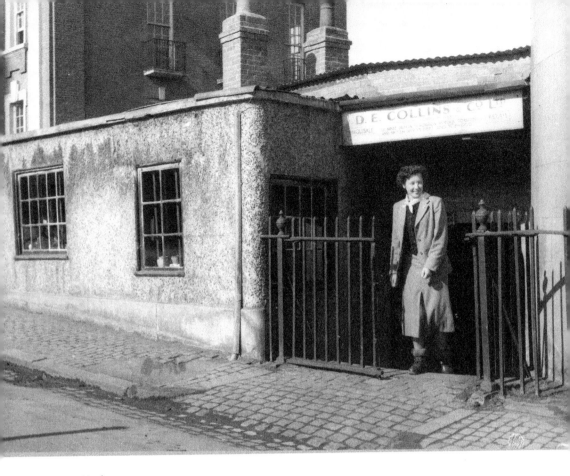

Priory Vaults

The Priory Vaults or Cellars photographed the year they closed, 1955. At No. 14 Priory Row these vaults, partly dating back to the old priory, ran under a number of houses in Priory Row and were the most extensive in the city. They were used by wine merchants as cool storage for their barrels and bottles of wines, sherries, ports and spirits. One of the first to use them may have been wine merchant David Wells of No. 11 Priory Row. The Collins family established their business here in 1784; in 1828 Joseph Collins, wine merchant, was running the business. He was succeeded by his son, D. E. Collins. It then passed to his nephew, who retained the firm's original name.

Walsgrave Hospital

The new Walsgrave Hospital being constructed among the fields of Walsgrave-on-Sowe in August 1964. The maternity unit opened in 1966 followed by the general unit in 1969. Holding nearly 1,000 beds, it was the largest hospital in Warwickshire. Demolished in 2007, the building was gradually replaced with the larger University Hospital, the first part of which opened in 2006.

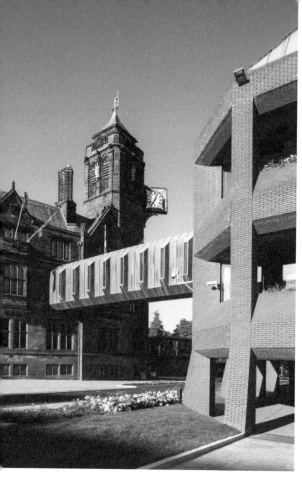

Left: Council House
This photograph, taken in 2014, shows the Council House with its copper walkway attached to Civic Centre 3, which is now owned by Coventry University. The bridge was removed in April 2017.

Below: Spire House, New Union Street
Spire House in New Union Street, photographed in 2014, was designed in the early 1970s by the City Architects Department. Spire House and Christchurch housed council offices and was considered an unusual design with sunken courtyard, rounded corner and variable roof heights. Having stood for less than fifty years, the building was demolished in 2017 for a new £36-million water park.

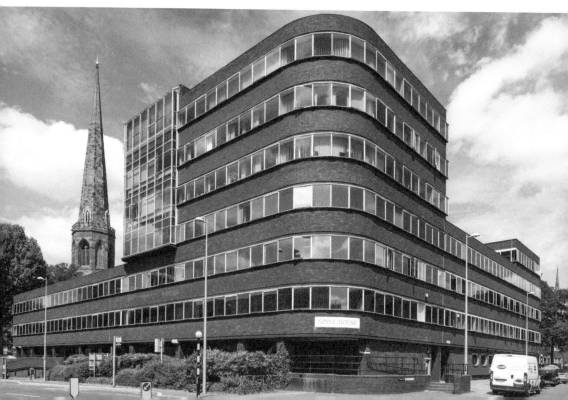

Lost Factories

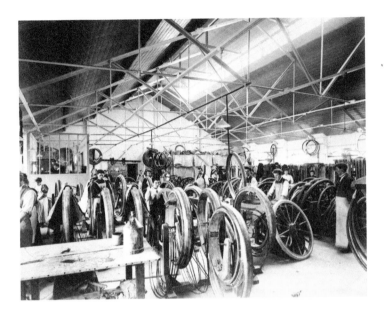

Dunlop Cycle Tyre Works

Over the last 200 years Coventry has built and demolished hundreds and hundreds of factories. During the nineteenth and twentieth centuries, particularly, factories were the most common place of employment. This photograph, taken in 1897, shows the Dunlop Cycle Tyre Works in Alma Street set up for the production of pneumatic tyres – the invention of John Boyd Dunlop.

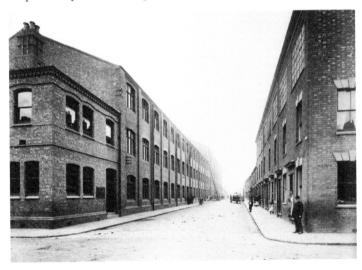

Dunlop Factory

This image shows the interior of the Dunlop factory in 1897. The building is notable for its lightweight metal roof. At this time Coventry, home to firms like Rudge-Whitworth, was one of the largest cycle producers in the world. So in Coventry Dunlop had a ready market for his product.

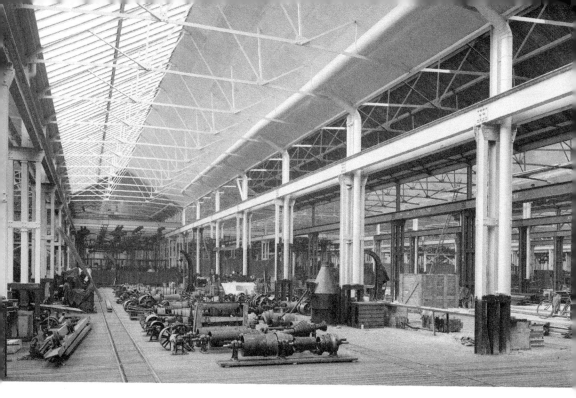

Alfred Herbert Works

The Alfred Herbert Works in July 1920. Alfred Herbert, later Sir Alfred, set up his machine tool manufacturing firm called Herbert & Hubbard in Upper York Street, Coventry, with William Hubbard in 1889. He later bought Hubbard out and the firm became Herbert Machine Tools, then in 1894 it became Alfred Herbert Ltd. By 1914 Herbert's employed 2,000 people. It grew through the century, becoming the largest machine tool manufacturer in the world. Knighted in 1918, Sir Alfred Herbert should also be remembered for the care he took of his employees and that he was a great benefactor to Coventry. The Herbert Art Gallery and Museum is named after Sir Alfred.

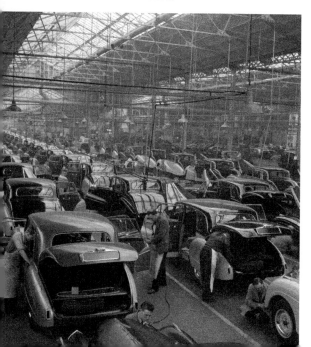

Armstrong Siddeley Works

A view inside the Armstrong Siddeley Works, Parkside, in 1954, showing the Sapphire car production line. The company was formed in 1919, an amalgamation of J. D. Siddeley's car company and Armstrong Whitworth. They transferred to the Parkside works and here made motorcars and aero engines. In 1952 the company exhibited the Sapphire at Earls Court. Production of these handsome cars, capable of 100-mph speeds, continued for a number of years as saloons and limousines; they even made them as automatics.

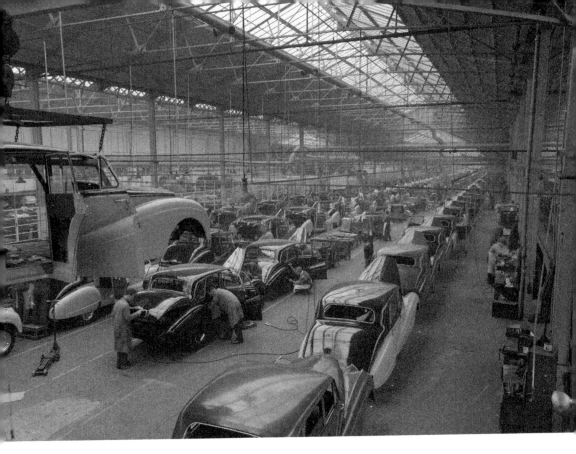

Sapphire
Another look down the Sapphire production line. Such views were once common in Coventry. Coventry produced our the car in the UK, and it once had more car factories than any other city in the world. The only production line vehicle built in the city today is the London taxicab.

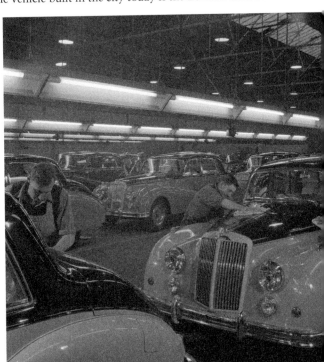

On the Production Line
Polishing cars on the production line in 1954. Armstrong Siddeley cars are perhaps not as well remembered as many other makes, but they were popular and arguably, in their time, some of the finest-looking cars on the road.

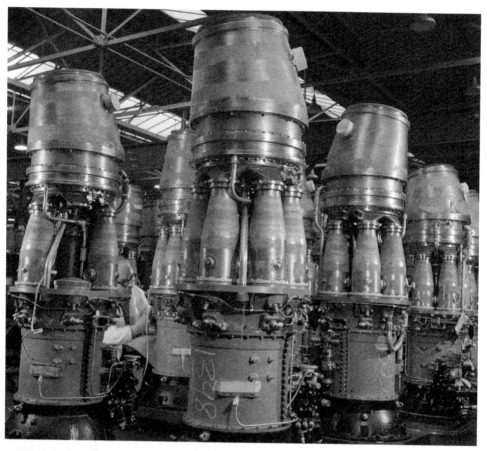

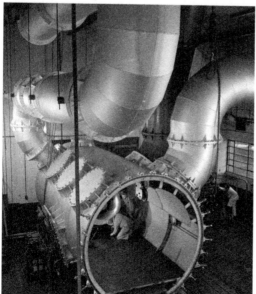

Above: Aero Engines
Finished aero engines in the factory. The
Sapphire engine was considered highly
reliable and the most successful second-
generation engine of its time. Sapphires
were used on Javelin delta wing fighters,
Victor bombers and some Hunter
fighters. The firm made aero engines
from the First World War – many named
after big cats.

Left: Snarler Rocket
Two men working on a large aero engine
at Armstrong Siddeley, possibly a Snarler
rocket engine.

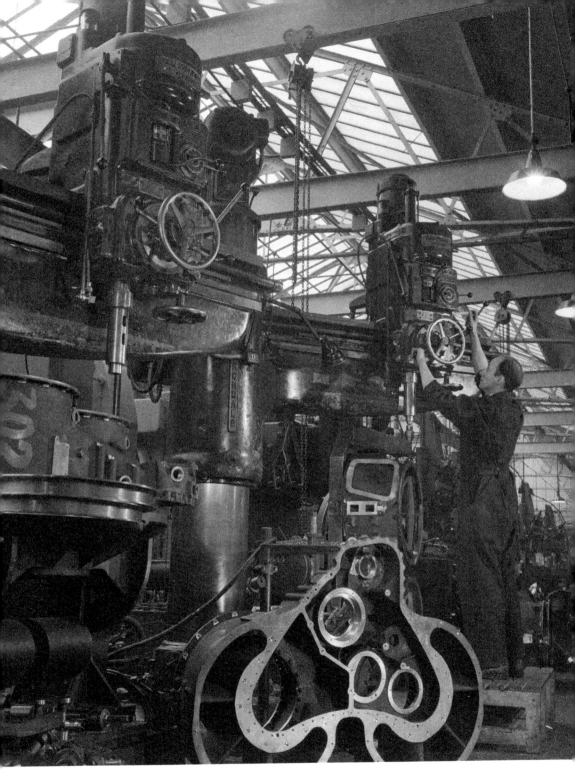

Armstrong Siddeley
Men working in the machine shop in Armstrong Siddeley's in 1954.

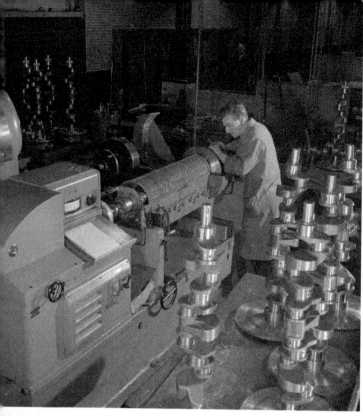

Left: Armstrong Siddeley
A man working a lathe at
Armstrong Siddeley in 1954.
This was once a common sight
in Coventry, but is now rare.

Below: Drawing Office,
Armstrong Siddeley
The drawing office at
Armstrong Siddeley in 1954.
Everything produced in
the factory was first drawn
in here.

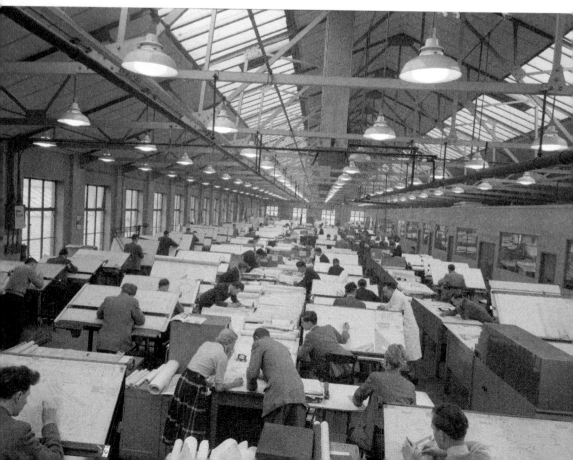

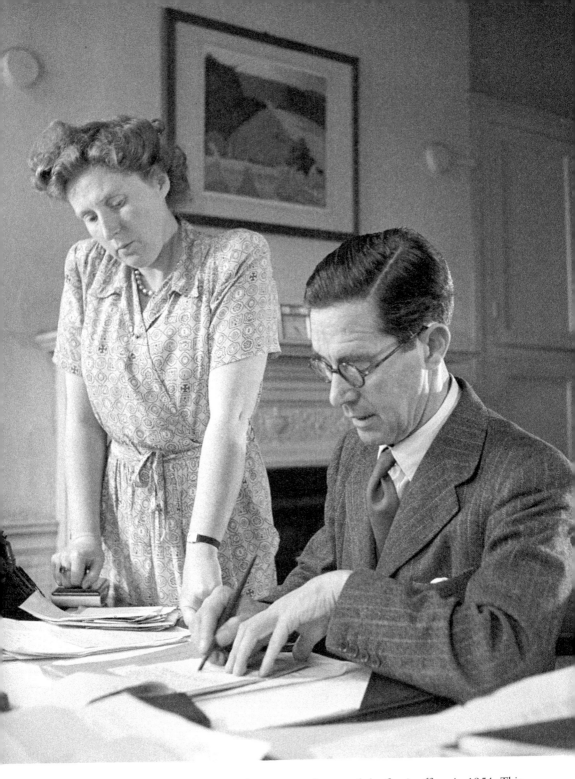

An Armstrong Siddeley manager and his secretary in one of the firm's offices in 1954. This photograph says a lot about its time ... so English!

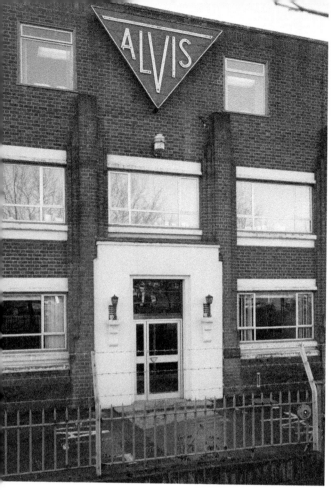

Left: Alvis Offices
Taken in 1986, this shows the main entrance to the Alvis offices on the Holyhead Road. T. G. John, formerly of Siddeley Deasey, established the Alvis Motor Co. in 1919. The company had a reputation for producing quality sports and touring cars. The last cars were built here in 1967. The building has since been demolished and is now the Alvis Retail Park.

Below: Alvis Offices
The extended frontage of the Alvis offices on the Holyhead Road, which later became the site of the Alvis Retail Park.

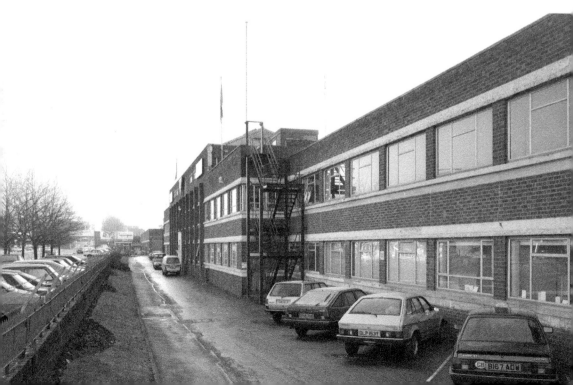

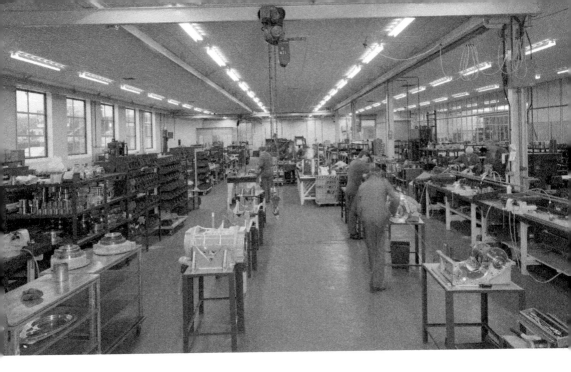

Above: Shop at Alvis
A view of one of the shops at the Alvis factory taken in 1986. From the Second World War Alvis also started producing high-quality military vehicles such as the Scorpion, Stormer and Spartan and aero engines.

Below: Alvis Factory
Inside the Alvis factory workshop in 1986, now gone. The company continued trading in Coventry until 1998 when production was moved to Telford.

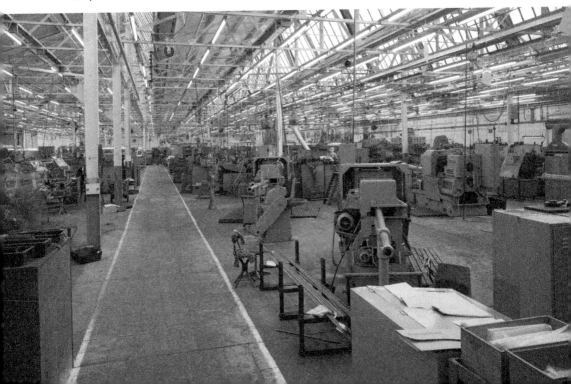

From the Air

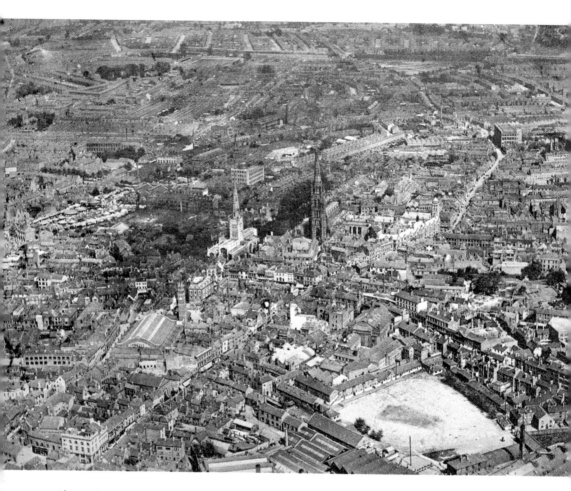

Above: Coventry City Centre
An aerial view of Coventry city centre taken in 1920. Holy Trinity can be seen centre left and to its right is St Michael's. The open square below is the Coventry Barracks parade ground, which was in use until the end of the Second World War. The long road before it is Smithford Street, which ran down from the present NatWest in Broadgate to St John's Church.

Opposite above: Radford
A view over Radford in 1920 showing Radford Road in the foreground; the garden bottom right belongs to Barr's Hill House, now the site of Barr's Hill Community College. The railway line swerves off to the left and the second crossing is Sandy Lane with the Daimler factory to the right. The straight road in the background is Foleshill Road.

Opposite below: Coundon Road
In the centre of the 1920s photograph is Coundon Road running past the gas cylinders into Hill Street. St John's can be seen at the bottom of the street and above the Barracks Square. To the left, Holy Trinity and St Michael's can be seen.

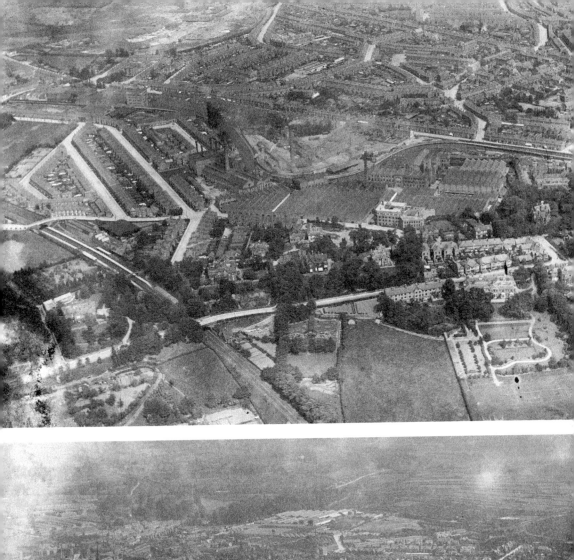
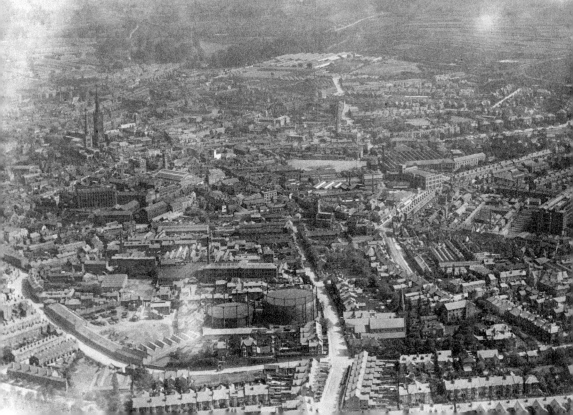

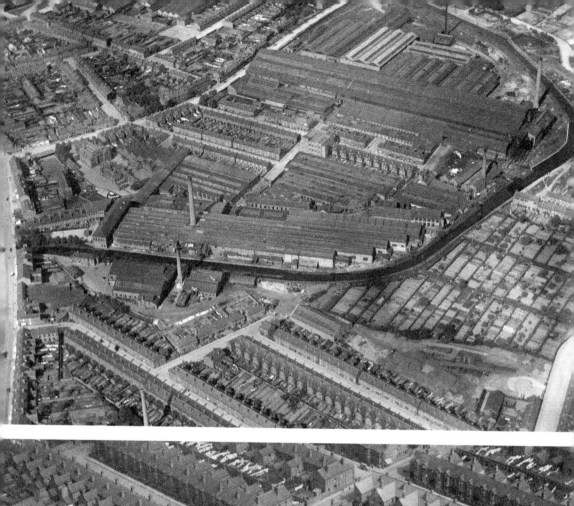
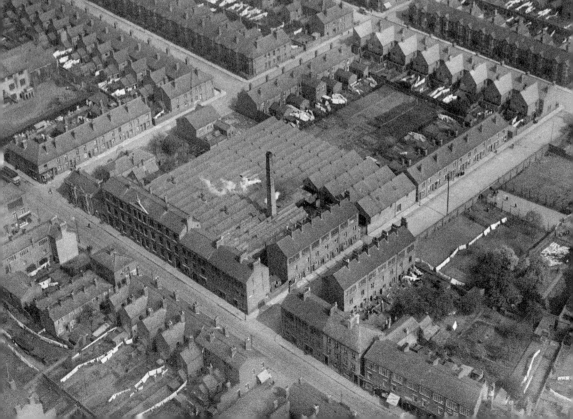

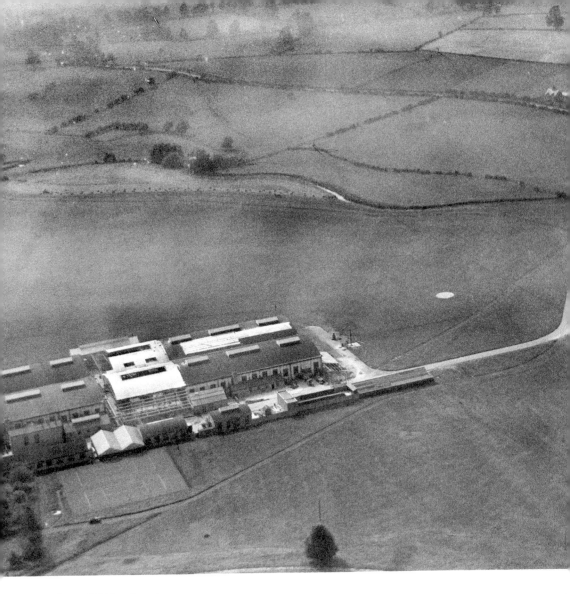

Above: Whitley Aerodrome

Whitley Aerodrome in 1927 was entered via a track off Abbey Road by Whitley Bridge. It was constructed using German prisoners of war but was never actually used as a military airfield. It was used by Armstrong Whitworth, and their Agosy passenger plane made its first flight from here in 1926. Armstrong Whitworth also flew the first prototype Whitley bombers from here – hence the name.

Opposite above: Coventry Ordnance Works

The Coventry Ordnance Works in 1924 set within the curve of the canal. Stoney Stanton Road runs on the left and above the works is Red Lane. During the war, soot was spread on the canal to hide the works, set in the distinctive curve. The ordnance works was one of the country's largest munition factories in the First World War, making massive ship's guns and munitions.

Opposite below: The Brittania Mills Coach and Motor Lace Works

The Brittania Mills Coach and Motor Lace Works in 1926 on the corner of Paynes Lane and Landsdowne Street, just below the old Highfield Road football ground.

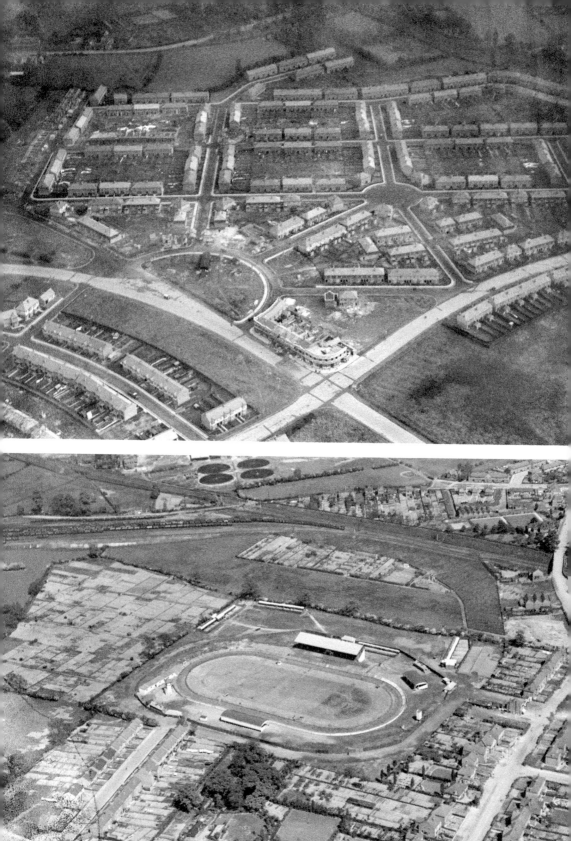

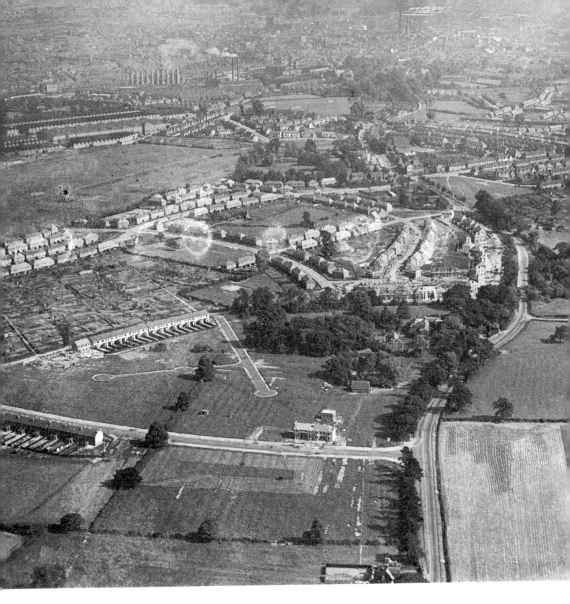

Above: Keresley
Wallace Road from left to right in the foreground in Keresley in 1931. Keresley Road runs on into Radford and behind Wallace Road, going left to right, is Sadler Road. The road at an acute angle is Chesterton Road.

Opposite above: Cramper's Field, Radford
A view over Cramper's Field in Radford in 1927. The 'D' is the green at Cramper's Field and the road by it, Moseley Avenue, and Butts Lane cuts across it. The 'V' off Moseley is Lawrence Saunders Road leading around to the Radford Road.

Opposite below: Greyhound Stadium
The greyhound stadium in Holbrooks in 1929. The road on the right is Lythalls Lane with Beacon Road heading toward the stadium on the left. The greyhound and speedway stadium was opened in 1928 and was closed in 1964.

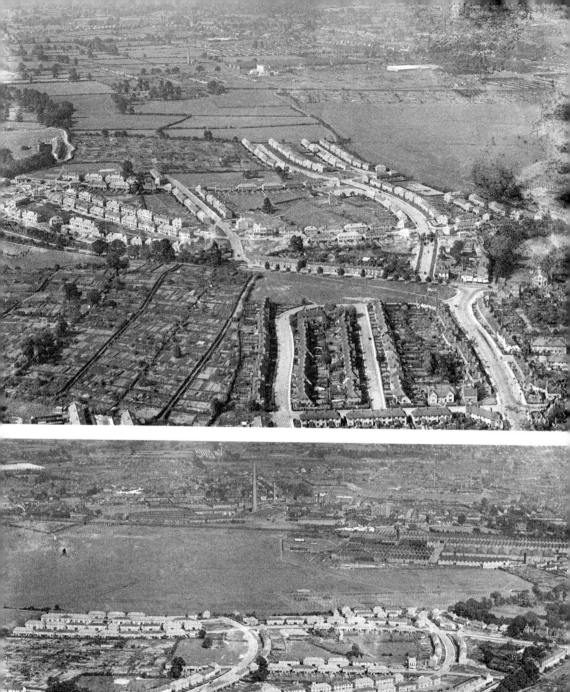
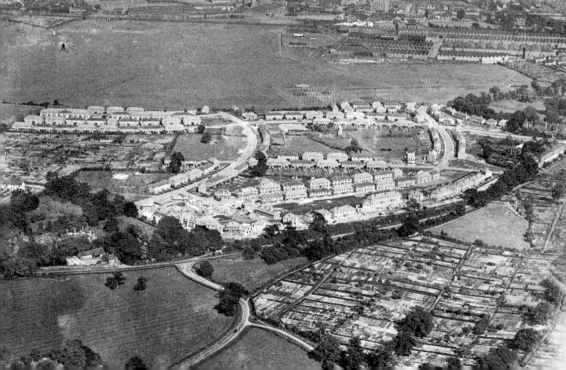

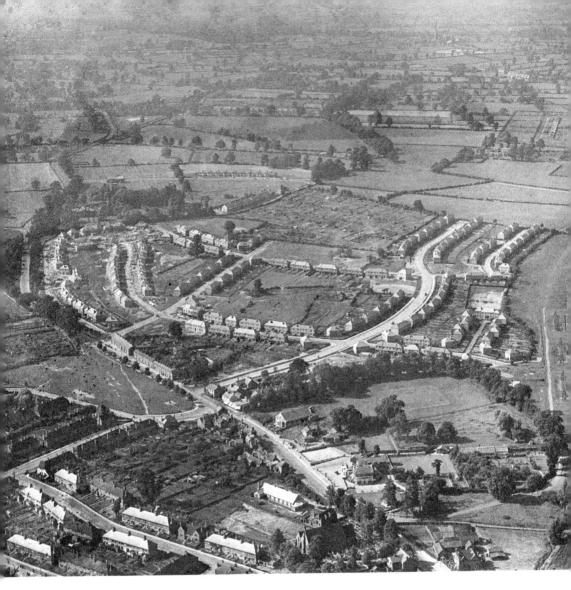

Above: Radford Common, Engleton Road and Dugdale Road
Taken in 1931, this photo looks over Radford Common (left), Engleton Road and Dugdale Road (left foreground). Radford Road runs left to right, the curved road beyond is Villa Road and the next road up on the left is Beake Avenue with its first houses. Bulwer Road crosses it.

Opposite above: Radford Common
This photograph taken in 1931 shows Holland Road in the foreground on the left. The road to its right is Poultney Road and the next road is Engleton Road. The grass sward above it is Radford Common. Radford Road runs above the common with Beake Avenue on the right.

Opposite below: Radford Allotments
Image taken in 1931 looking over Radford Road by Radford allotments looking towards the open ground and the Daimler works.

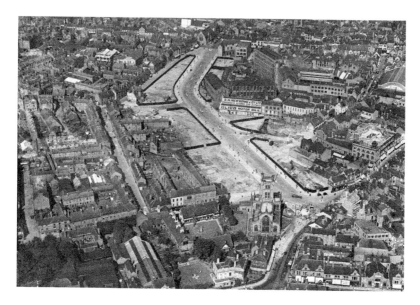

Corporation Street

Taken in 1931, this image shows a marked-out area cleared for the laying out of Corporation Street. In the foreground on the right at the end of the cleared area is St John's Church with Spon Street before it and Hill Street behind.

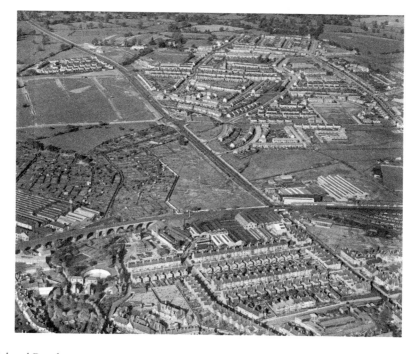

Holyhead Road

Taken in 1934, this image shows the Holyhead Road running diagonally from left to right. Beyond the housing on the left is the Alvis works and allotments beyond. On the right is Moseley Avenue; Four Pound Avenue was laid out slightly later.

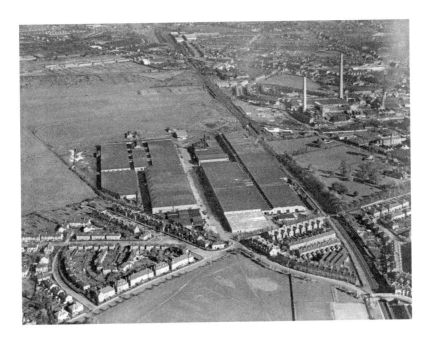

Daimler Works
The Daimler Works at the top of Sandy Lane in 1934. Before it is Radford Wreck next to Lydgate Road. The open grass area beyond was Radford Aerodrome in the First World War. The railway runs off beside it.

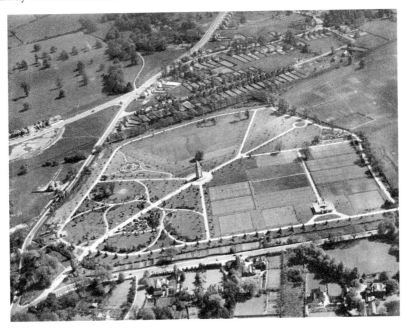

War Memorial Park
The War Memorial Park photographed in 1937. Kenilworth Road runs below it and Leamington Road above.

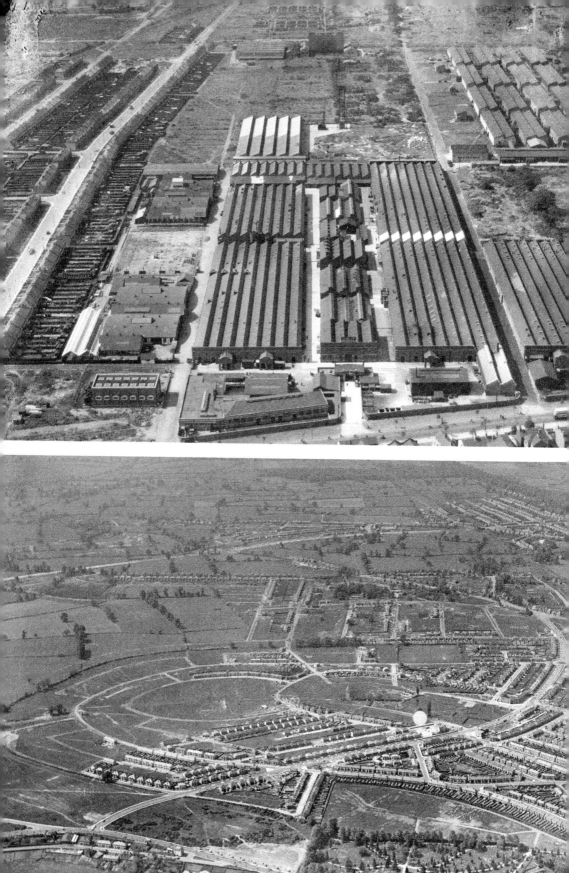

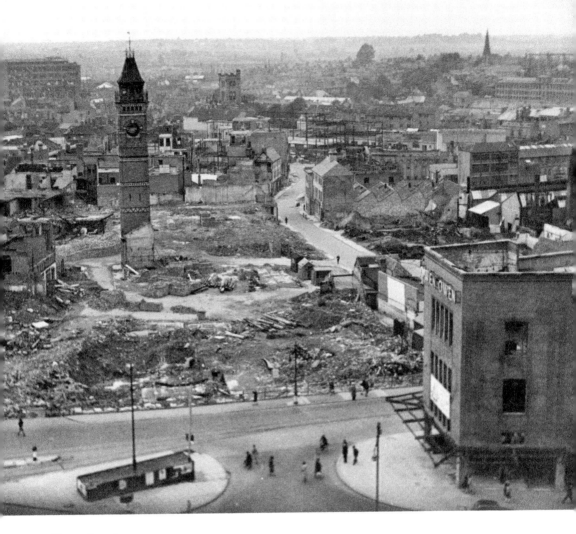

Above: Broadgate

The bottom of Broadgate taken on 11 October 1941. This area up to this date had suffered three major raids and a number of smaller attacks. The main area is clear, but not worth rebuilding yet. On the right is the first Owen Owen building, destroyed in November 1940. The road behind is West Orchard. The market clock tower is still standing; its clock mechanism and bell now works the present Godiva clock in Broadgate. It was demolished in December 1942.

Opposite above: Dunlop Works

The Dunlop Works in Whitmore Park/Holbrooks taken in 1937 with Burnaby Road on the left. The narrow road running through the factory also ran through Swallow Sidecars, soon to be SS then Jaguar Cars. This was also previously the site of the massive White & Poppe munition works during the First World War. The 'Dumps' storage for munitions was in underground bunkers – top left of the picture.

Opposite below: Cheylesmore Estate

The new Cheylesmore estate being laid out, minus many houses, in 1939. Quinton Pool is in the foreground right, and the curved road above is the Daventry Road.

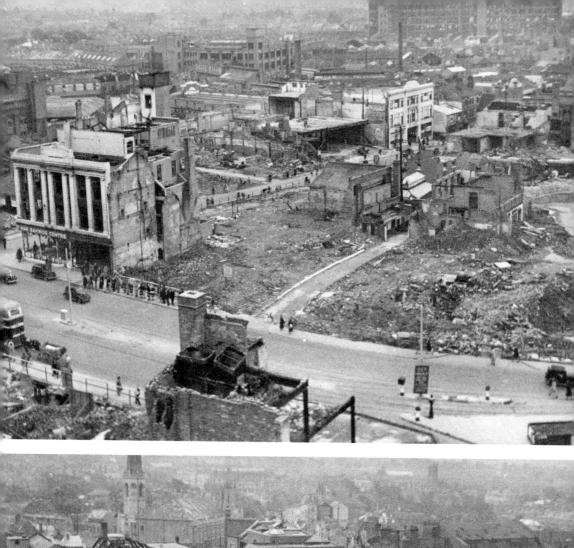
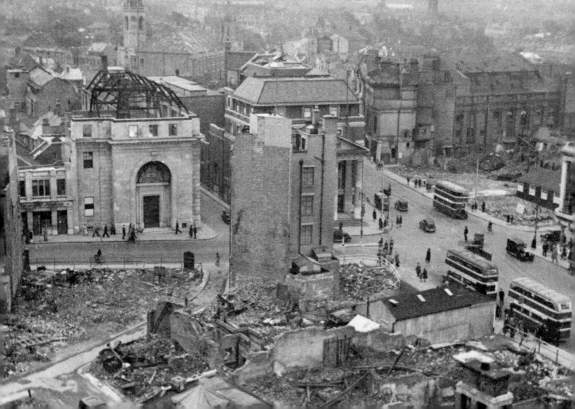

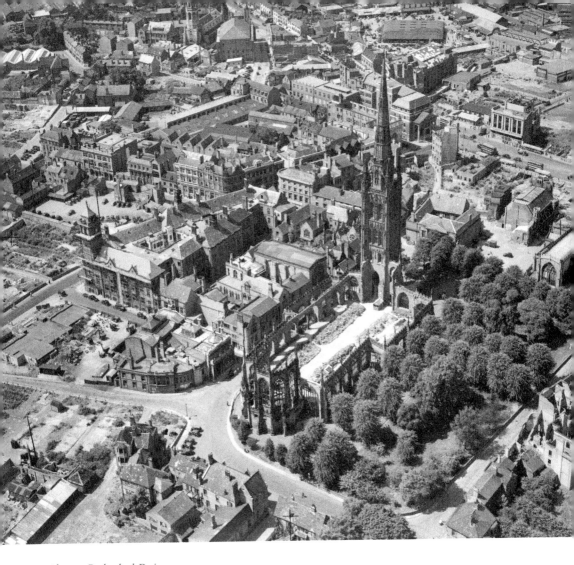

Above: Cathedral Ruins

Looking down on the cathedral ruins in 1946, Bayley Lane to the left was flattened on 14 November 1940. The most interesting feature of this photo is St Michael's churchyard is full of trees, like woodland in the heart of the city. This churchyard was originally much bigger, extending across Priory Street and down to the now culverted river in Fairfax Street.

Opposite above: Broadgate

The same date as the previous picture, this one shows the middle of Broadgate. The white building on the left is the old Burton building standing on the corner of Smithford Street. During the recent paving of Broadgate the floor tiles at the entrance to this shop could still be seen 20 feet from the Godiva statue. The small road going off Broadgate is Market Street, leading into Market Square. The large building in the distance is the old GEC factory.

Opposite below: Broadgate

The same date again looking across the top of Broadgate. The edge of the white Burton building is on the right and to the left is Lloyds Bank. The National Westminster is partially hidden by the only standing building on the corner of Pepper Lane and High Street. Behind can be seen Christchurch tower and spire.

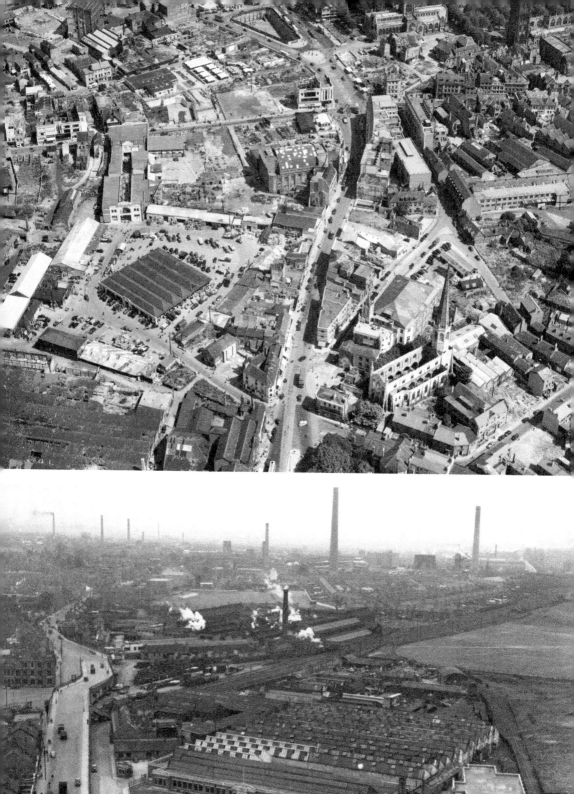

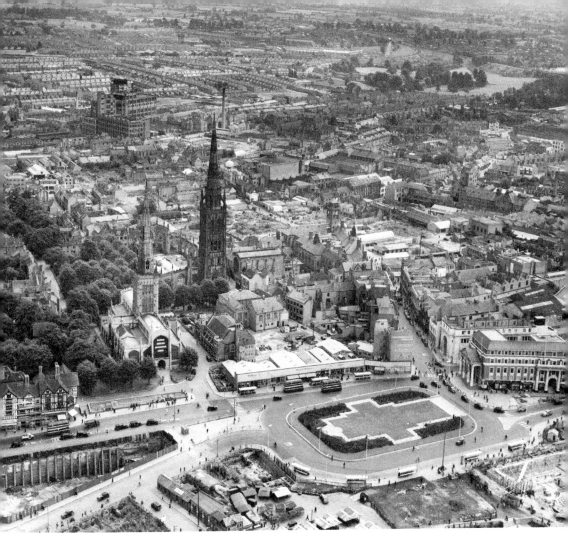

Above: Broadgate, 1949

Broadgate in 1949, showing Trinity and St Michael's ruins beyond. The new Broadgate Island can be seen and on the left the basement of the original Owen Owen store; this basement is still used by the present Primark Store, built on the top end of the site. On the right the whole of the National Westminster building can be seen running into Hertford Street. The whole of Broadgate is, of course, now pedestrianised.

Opposite above: Hertford Street and Broadgate

Taken in 1946, Hertford Street can be seen heading straight up to Broadgate. On the left is the old barracks square, then in 1946 the Barrack's Market. The road running beyond it is Smithford Street; beyond on the left are Trinity and St Michael's. The barracks came into use in 1793, mainly used by royal artillery regiments. It was also home to troops of Dragoons. It was used throughout the First World War and into the Second World War, then as we see, it became the site of a market.

Opposite below: Brico Rings Piston Works

Brico Rings Piston Works in 1948 in Holbrook Lane, known more commonly as the Brico. It is interesting to note how much industry was about at this time with the abundance of chimneys.

About the Archive

Many of the images in this volume come from the Historic England Archive, which holds over 12 million photographs, drawings, plans and documents covering England's archaeology, architecture, social and local history.

The photographic collections include prints from the earliest days of photography to today's high-resolution digital images. Subjects range from Neolithic flint mines and medieval churches to art deco cinemas and 1980s shopping centres. The collection is a vivid record both of buildings that are still part of everyday life – places of work, leisure and worship – and those lost long ago, surviving only in fragile prints or glass-plate negatives.

Six million aerial photographs offer a unique and fascinating view of the transformation of England's towns, cities, coast and countryside from 1919 onwards. Highlights include the pioneering photography of Aerofilms, and the comprehensive survey of England captured by the RAF after the Second World War.

Plans, drawings and reports provide further context and reconstruction artworks bring archaeological sites and historic buildings to life.

The collections are housed in a purpose-built environmentally controlled store in Swindon, which provides the best conditions to preserve archive items for future generations to enjoy. You can search our catalogue online, see and buy copies of our images, as well as visiting our public search room by appointment.

Find out more about us at HistoricEngland.org.uk/Photos
email: archive@historicengland.org.uk
tel.: 01793 414600

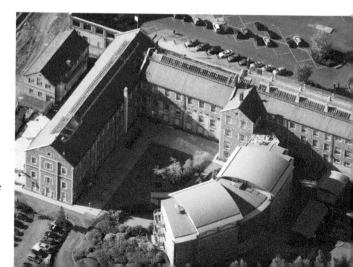

The Historic England offices and archive store in Swindon from the air, 2007.